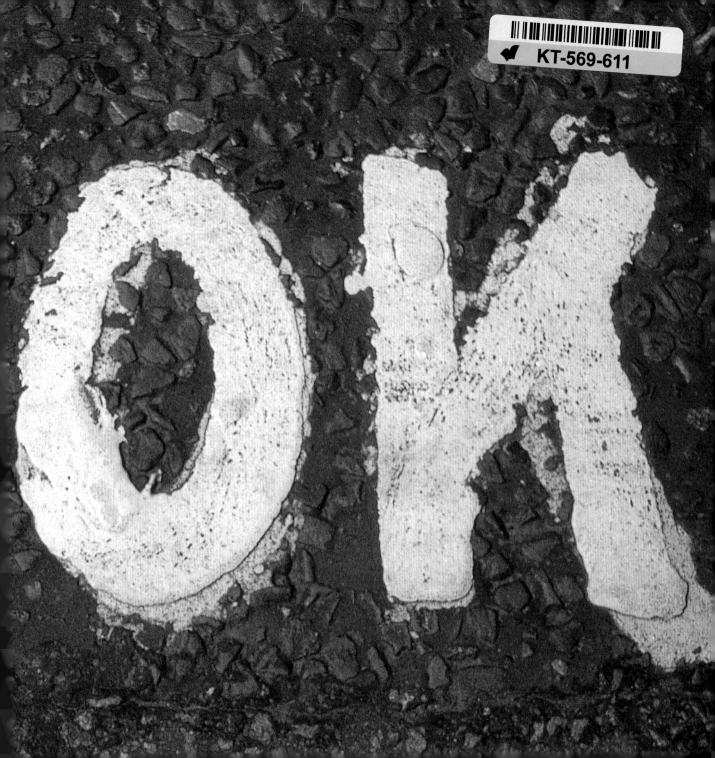

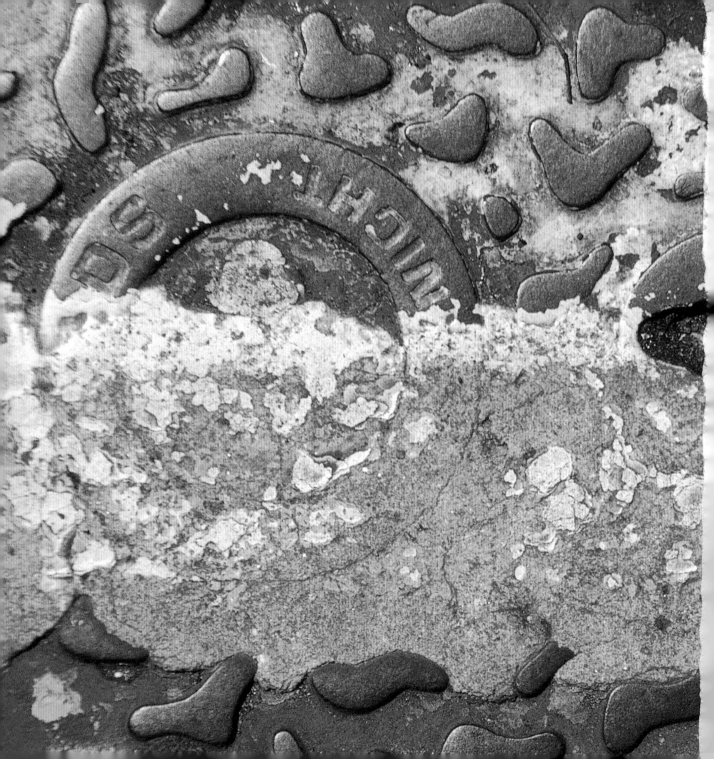

JACOPO PAVESI - ROBERTA PIETROBELLI

STREET COVERS

LONDON PARIS BERLIN AMSTERDAM ROME

THE VIEW BENEATH ONE'S FEET: OVERSIGHT AND *ÜBERSICHTLICH* WHEN EYES ENCOUNTER MANHOLES

Rolando Bellini

This exploration has permitted the discovery of otherwise neglected, abandoned objects, which have never before been taken seriously. The protagonists are two young people who work in Varese: Roberta, a designer and artist who studied at Brera (an area of Milan), and Jacopo, an architect. During their curious wanderings these two encountered a constellation of slabs in all shapes, dimensions and materials.

The general observation of this series of rectangular, round and elliptical plates made from cast iron, steel, wood and other materials, creates an unexpected effect: of viewing the invisible. A series of patterns dominated by geometry is the cause of a surprisingly intense emotional response. Shields in which dragons, stars, horses or other animals from a certain age-old heraldic repertoire dominate the coats of arms of half of Europe, are liberally mixed with ornaments reminiscent of other universes, from the simple geometry of clear Euclidean roots, to neo-baroque lots and games afferent to non-Euclidean geometry. Alongside the expected patterns and symbols, diverse memories and moods are evoked: the graphic repertoire of the first advertising billboards; the charm of the nineteenth century; the sounds, lights and smells of coffee-house concerts in Paris and London, or the continuous sound of running water from the baroque fountains lining the streets of Rome. Art Nouveau (sinuous lines) and Art Deco (geometric lines) have offered, particularly for fabrics and paper, vast decorative repertoires, and it is of these one thinks when observing these individual objects as a whole.

A perceptual change takes place, a re-examination of the history and the objects themselves that brings about an unexpected impact between the real and the fantastic. And all of this because of an accidental discovery: being taken by the hand by two curious young people who rather than having their heads in the clouds have them anchored to the ground, and therefore search through every crack of it. Frequently their subjects conceal worlds under the surface of certain European city streets the two have explored together, inch by inch. Under one of these slabs is a hidden deposit of snow, under another is a gas valve which recalls a famous painting by Balla of a gas streetlight. Even their appearance is unnerving: their surfaces exhibit geometric patterns, trademarks, structures in relief which seem to be connected to old marble gratings, ancient cathedral windows, or Javanese batik or who knows what else; perhaps a decorative detail from a

Gaugin painting. There are also figurative compositions reminiscent of the Star of David, the Rosicrucian Order or other secret societies associated with the Cabal, theosophy, and much more.

On the whole these are simple forms, with elementary geometric patterns. However, their very patina, their deterioration on being used, the dulling caused by the deposit of extraneous material, all of these factors constitute their very skin and bring to the foreground the material from which these objects are made, fuelling the most reckless perceptual reactions, bringing to life dreams and thoughts, ideas and adventures. And I think it is precisely all of this which induced Roberta and Jacopo to make their trip, to make a diary of images and imprints which, in part, now finds a translation in a vade-mecum of images for the new explorers of the new millennium. It is also a kind of playful challenge arising from one's gaze falling onto one or two shining manhole surfaces. An audacious re-mixing of oversight and *übersichtlich* (German for 'surveyable') which surprises and stimulates you. Your gaze happens to drop to your feet, and you observe that which you had always missed: where you put your feet, on what pavement, on what textures, materials and forms you are walking when strolling down the street.

Among the many unexpected elements you tramp on with such nonchalance, barefoot or in high heels, on the surface of every post-modern or neo-modern city street, it is the street covers which catch one's eye, because in them order, meaning and function interact.

However, their charm does not end here. These unexplored items create a new opening into ornamentation and demand an adequate interpretation. Are we in a different universe altogether, or at least on the edge of one? Is that what our two guides want to say? Yes. A new world, which requires new perceptive parameters.

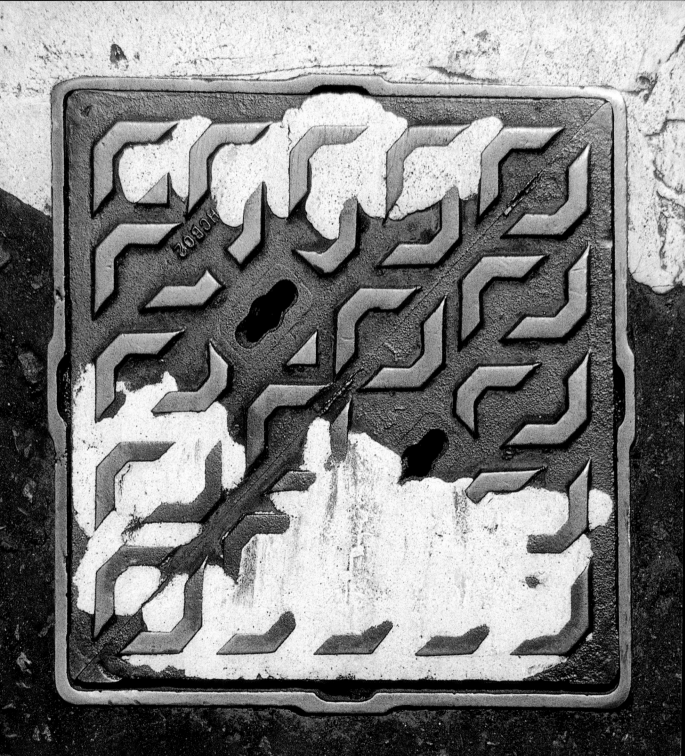

AN OPEN-AIR METROPOLITAN ART GALLERY

Jacopo Pavesi

Roberta Pietrobelli

It all began by chance: walking down the street with our eyes to the ground, we realised that a common and little thought-of object could actually be extremely curious and fascinating, possessing aesthetic, communicative and even artistic attributes.

We began viewing the manholes with greater interest: firstly those we came across along the streets we walked down on a day-to-day basis, then pursuing more detailed research which allowed us to select and catalogue a huge number of different types of manhole from some of the most famous streets in Europe.

This venture turned into a kind of treasure hunt, in which we were always on the lookout for new manhole typologies: always strange, full of history – and previously unnoticed. It was an uplifting experience. Suddenly an enormous open-air metropolitan art gallery opened up in front of our eyes consisting of objects that, apart from offering a considerable selection of wonderful and surprising motifs, showed us the progress of evolution and technologies which are the basis of our everyday life.

Above all, this experience has enabled us to become more aware of the urban environment we live in; to appreciate that there are many aspects of the city that we previously ignored, which had never aroused our interest or curiosity. Acquiring knowledge of all the utilities and technologies that enable a city to function led us to develop a feeling of civic duty, and created a premise for safeguarding the urban environment.

It is to be hoped that on the one hand our initiative can offer a contribution towards the discovery and evaluation of such an important object, and on the other that it will act as an invitation to everybody to widen their awareness and learn to respect each aspect of the urban landscape – to consider other details which, like the manholes, may appear insignificant at first glance.

Just as in the protection of nature one needs to know all aspects of flora and fauna, it is vital to understand everything in the urban environment that allows the city to function.

MANHOLE COVERS

Fabrizio Todeschini

The entry to a variety of underground service ducts, the manhole cover is part of that family of objects that characterise and render meaningful the urban landscape. Its presence announces the existence of all those services which improve the quality of life, signifying progress and the 'civilisation' of the urban spaces in which we live. We are dealing with a significant repertory of items which comprise the 'urban set-up', an indispensable system of equipment which, if distributed throughout a pre-planned area or according to an impeccable urban project, is capable of determining the qualitative level of public spaces.

The manhole covers, like lampposts, electricity cables, public telephones, post boxes, telegraph poles, underground exits, road signs and urban support equipment, act as easily recognisable reference points across the urban panorama. These reference points communicate the underground presence of gas, electricity, water, telecommunications, transport systems, information and digital technologies that constitute city life.

The manhole cover is a fascinating industrial product, full of meanings though simply made. The fact that these covers are regularly trodden on and ignored certainly does not mean they lack a precise function, a history, a tradition, an aesthetic-environmental make-up or, above all, their own identity and dignity. The manhole cover separates, but at the same time consents communication between the visible and invisible urban environment. It is a fused metal lid that reveals the presence of a mysterious subterranean world consisting of tunnels, ducts, conduits, waterways and sewers. It is an almost unknown world, but of undoubted importance, guaranteeing the services we use on a daily basis.

The advent of the manhole cover on the urban landscape coincided with the arrival of the various services and technologies that have contributed to the progress and improvement of city life. All over the civilised world, from New York to Paris, from London to Milan, from the largest metropolis to the smallest suburb, wherever these services exist it is possible to find manhole covers. They come in various shapes and forms, using different materials and having diverse decorations, inscriptions, opening mechanisms. Yet to the inattentive observer they can seem uniform and insignificant. The various physical and technological differences indicate the place and era of production, the city on whose streets they lie, the type of service they conceal, and the company in charge of that service.

The first manhole covers were made in stone; following the industrial revolution cast iron was the most commonly used material, but there are also manhole covers made from steel, aluminium, brass and so on. Nowadays the smaller covers are moulded in PVC.

The most common forms that can be noticed when making a catalogue of these objects are either round, square or rectangular, but there are also manhole covers that are oval, elliptical, pentagonal, hexagonal. The dimensions vary, but we can put them into two principal categories: the smallest are around 20cm in diameter and are normally used for closing off gas and oil pipes. The larger covers are around 50–80cm in diameter, allowing personnel, equipment and materials to enter for repair and maintenance work. The manholes used for drainage and rainfall collection come under the latter category.

The great variety of decorations and inscriptions on their surfaces is of great interest, both at an artistic and at a communicative level. The manhole cover's texture, as well as characterising the type of service supplied and for which city, also has a structural function: to lessen the weight of the object via a series of decorations and designs on the upper part and grilles on the lower part.

Certain information can be gleaned from the decorative style, the date of production and the logo of a foundry or manufacturer, which may or may not still be in existence. To a certain extent this information constitutes the historic heritage of the city and is witness to the evolution of the city itself and the services it provides. Along with other components of the urban set-up, it can contribute to determining how the city presents itself to the rest of the world.

This information is destined to die out or evolve in the manhole covers themselves, which over the years are removed and taken back to the foundries for recycling. The old covers are replaced by new models with different technical and aesthetic characteristics, holding up-to-date information on the level of development of the environment in which we live.

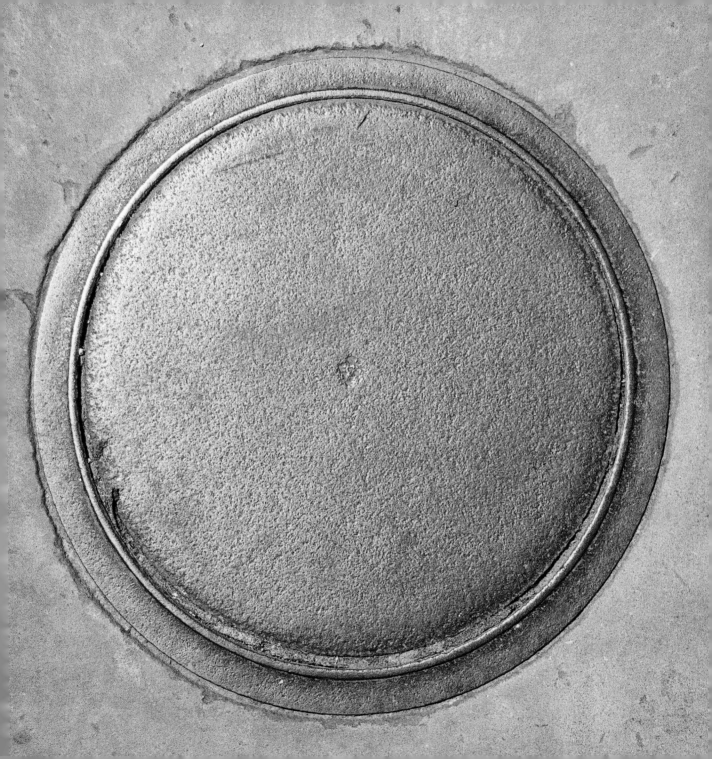

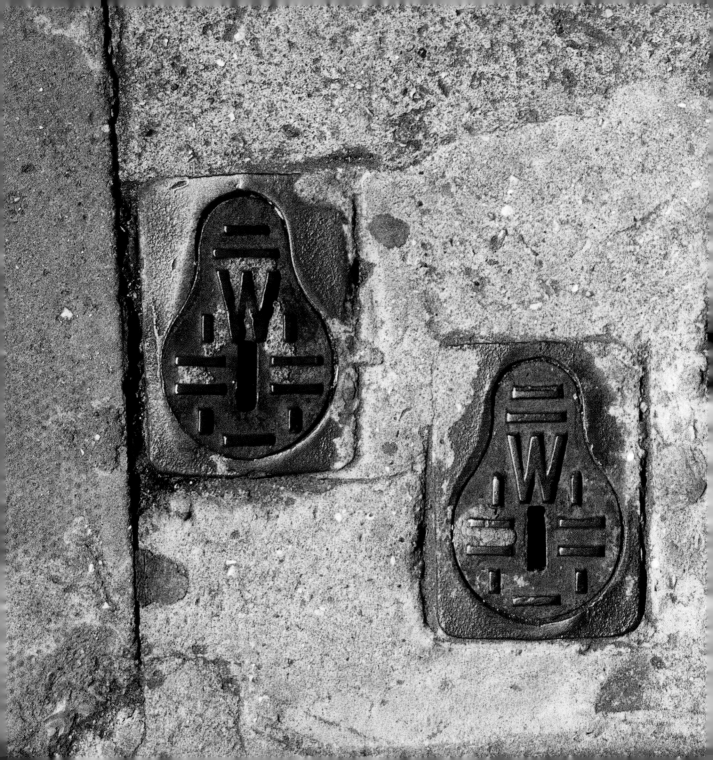

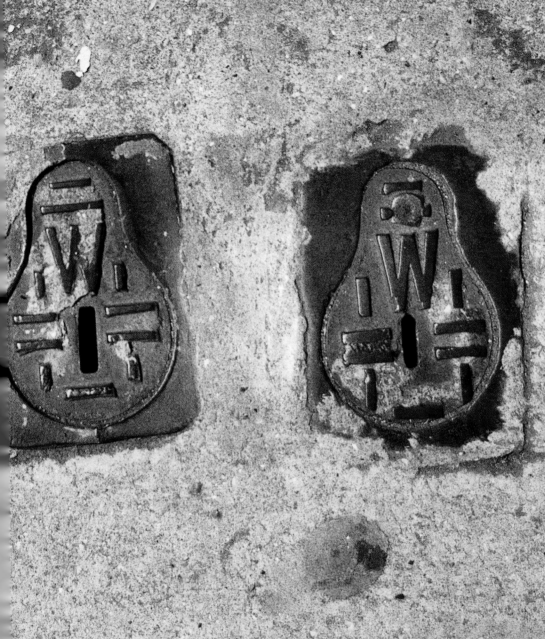

LONDON

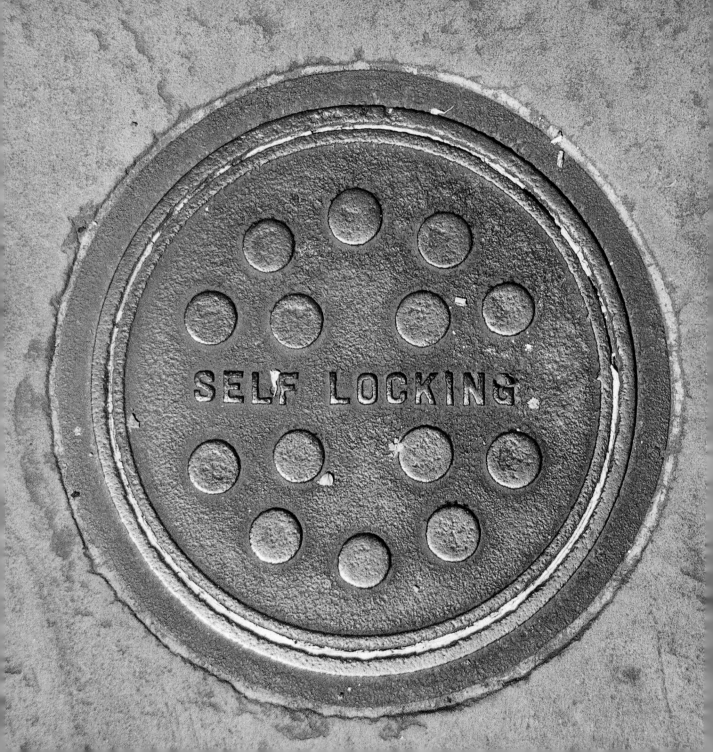

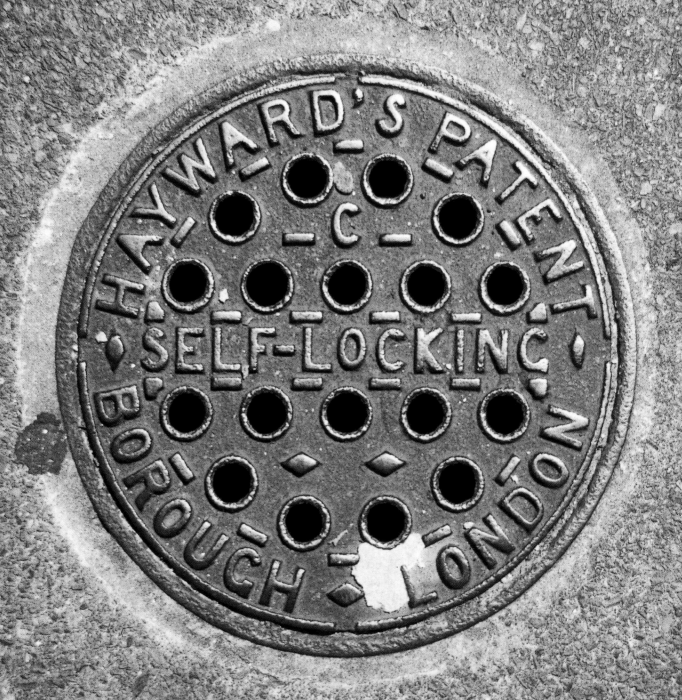

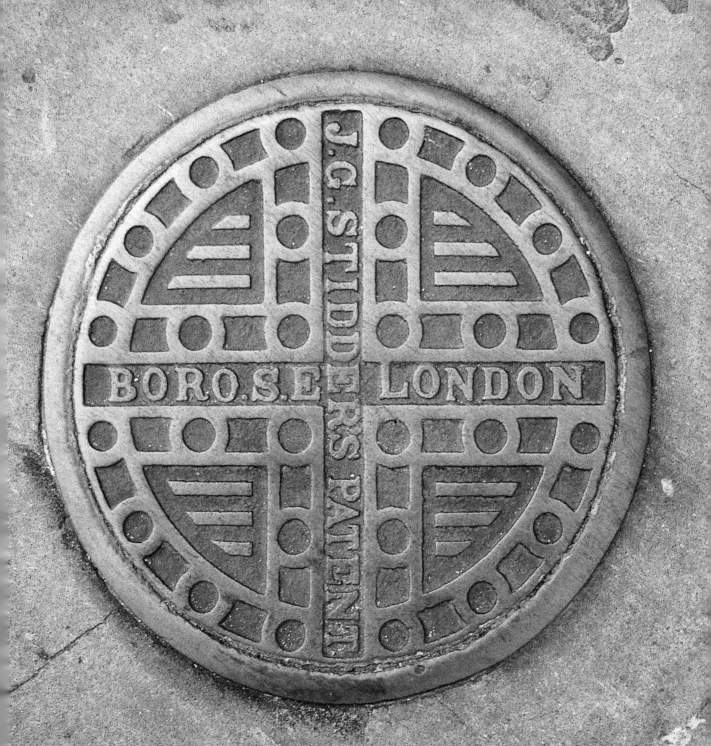

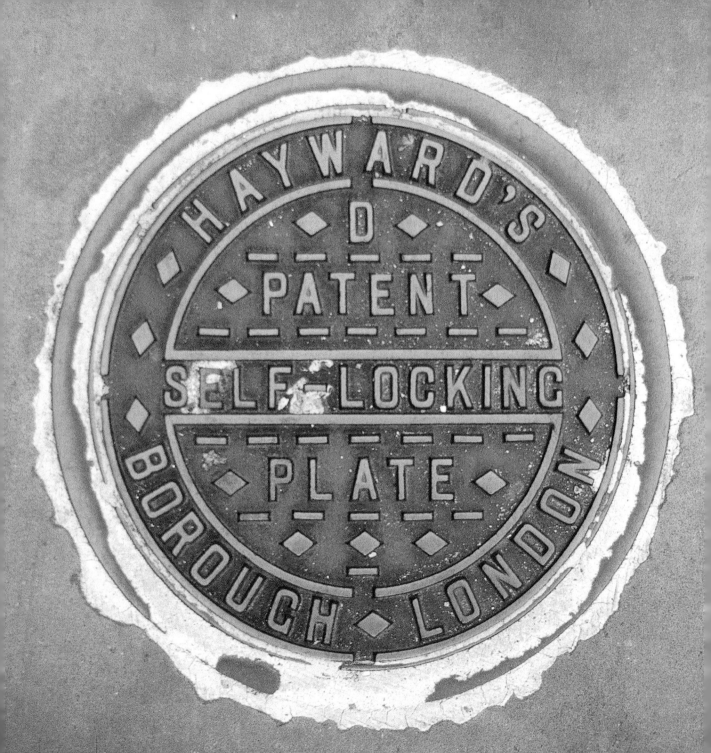

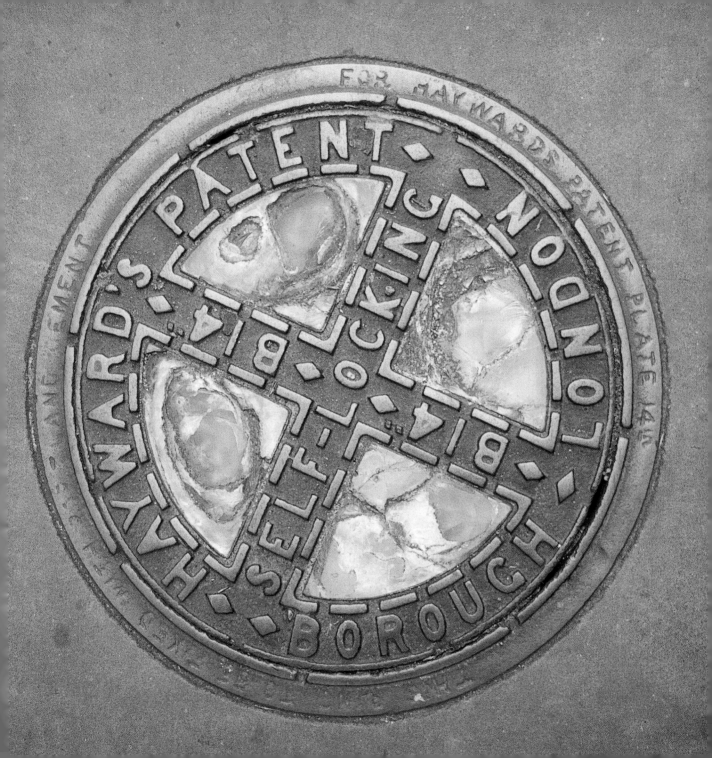

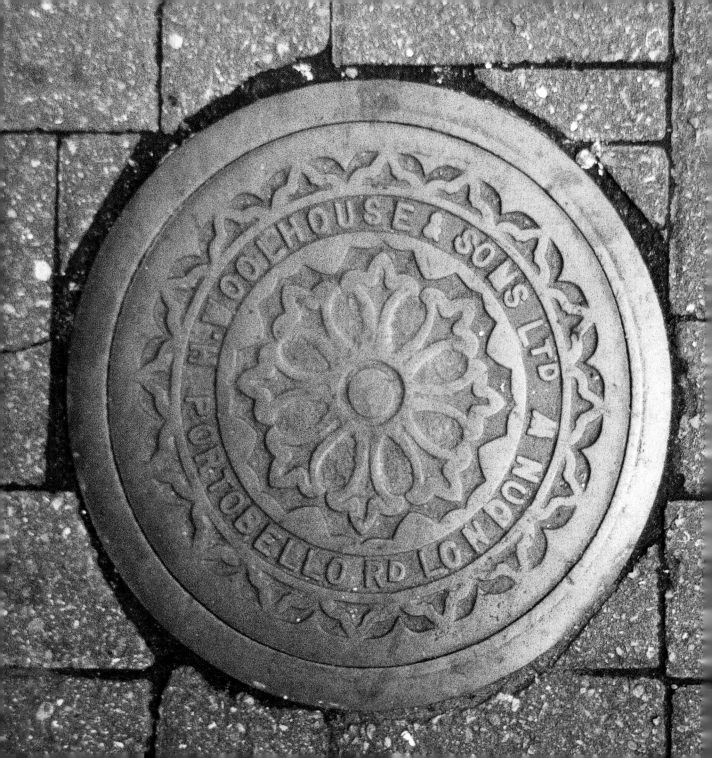

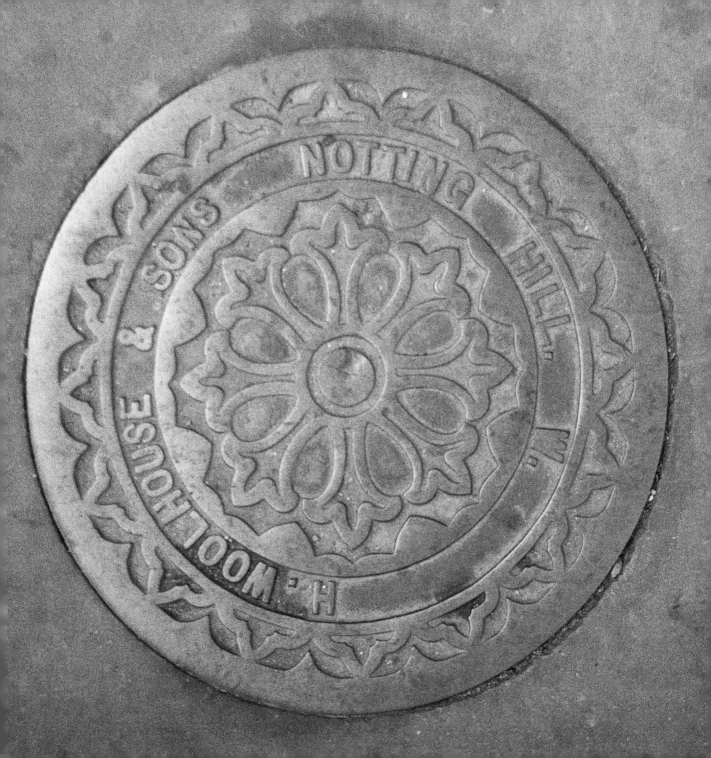

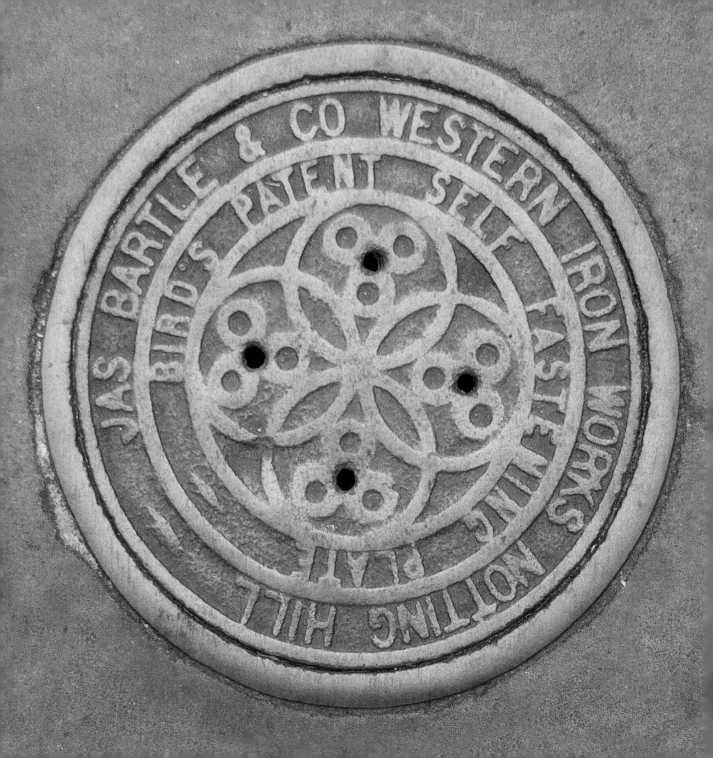

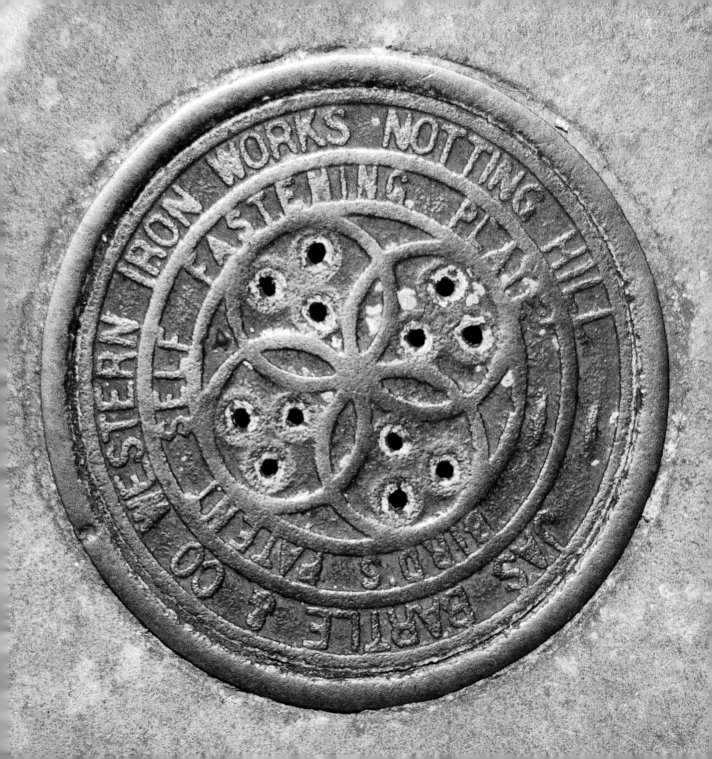

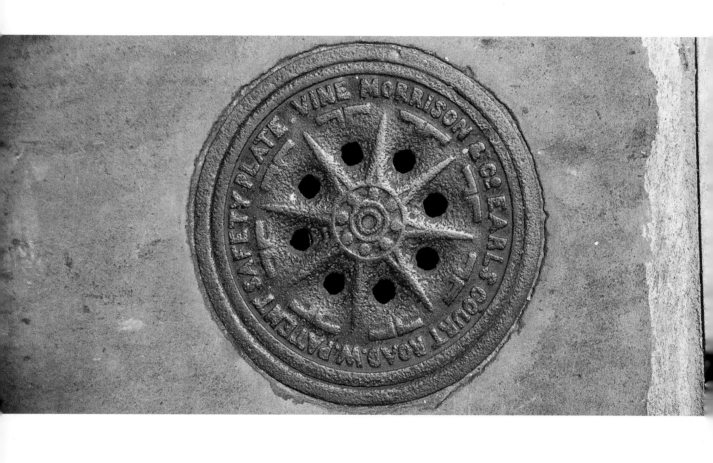

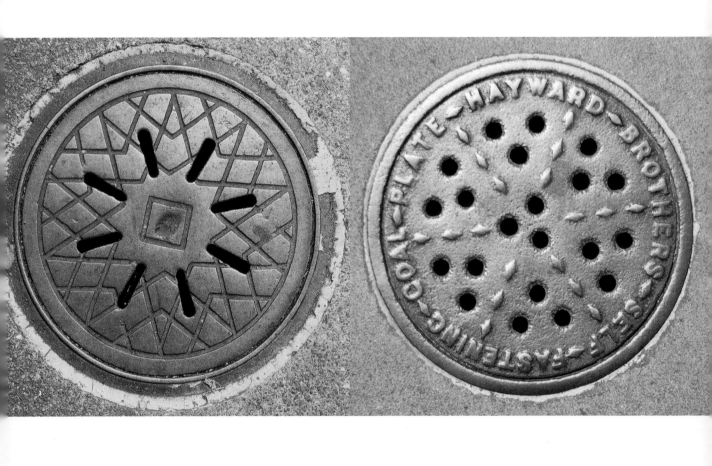

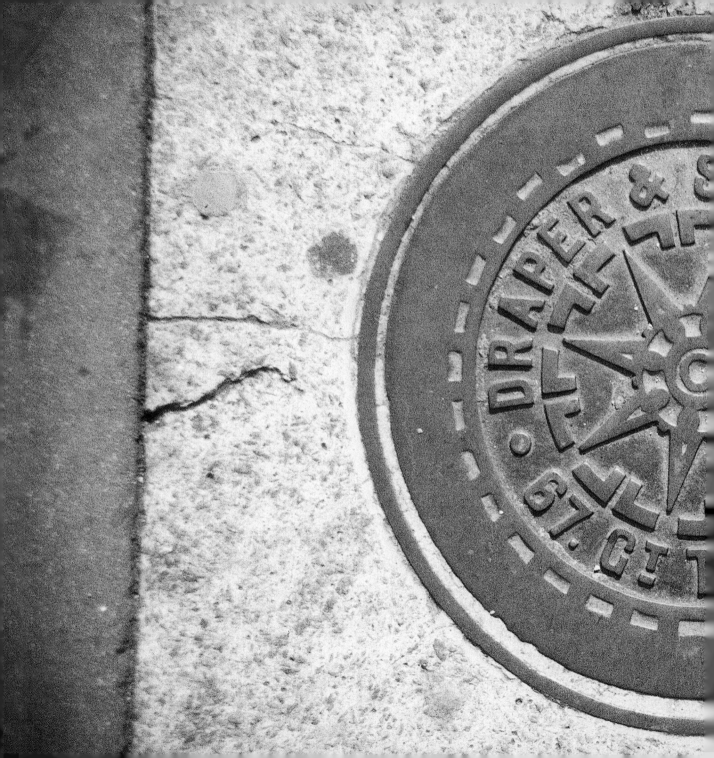

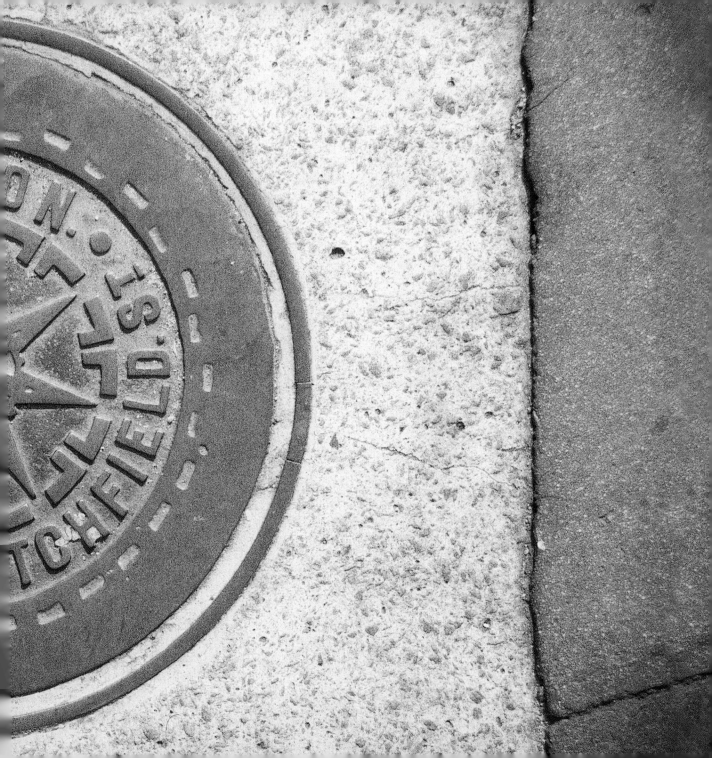

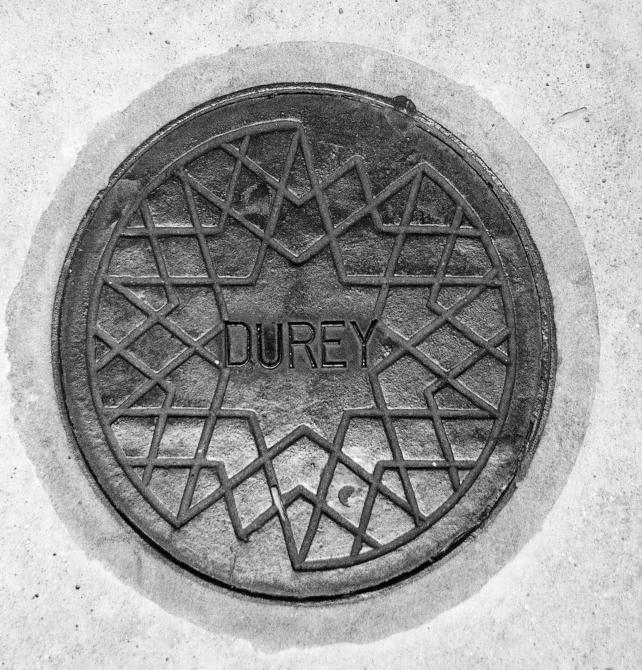

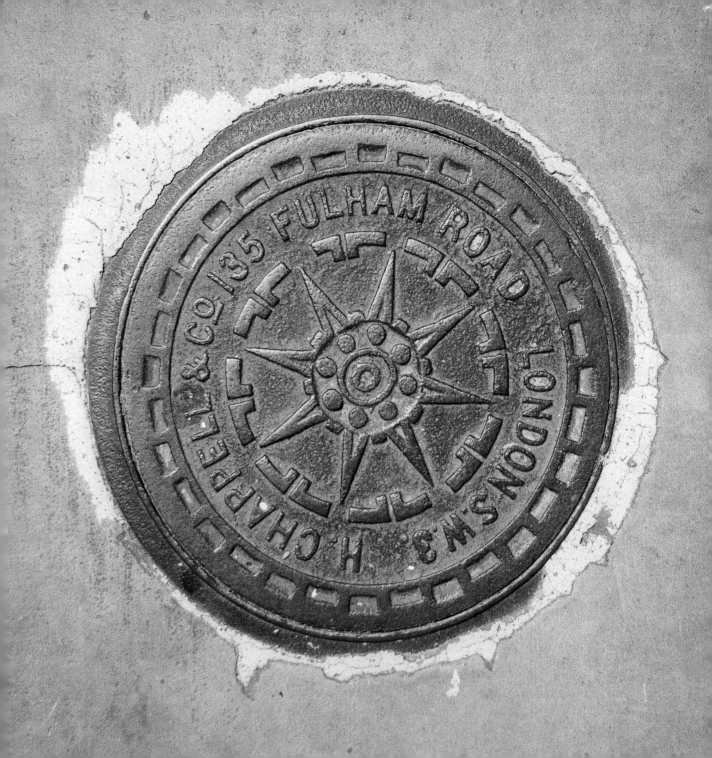

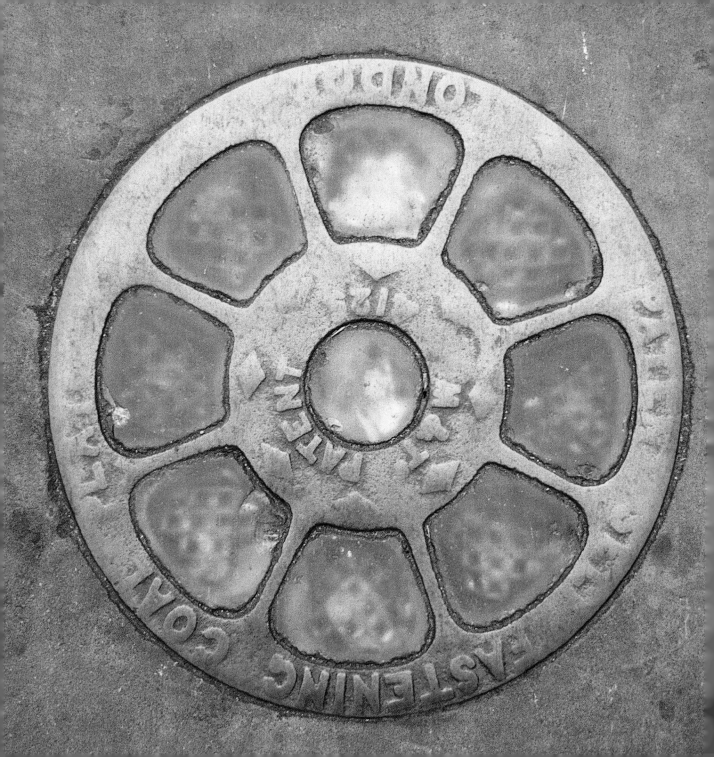

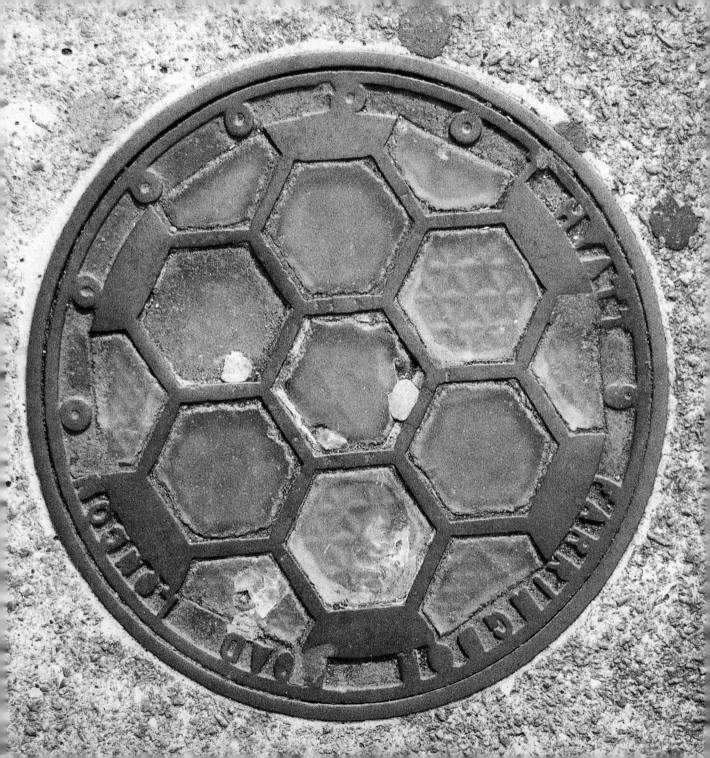

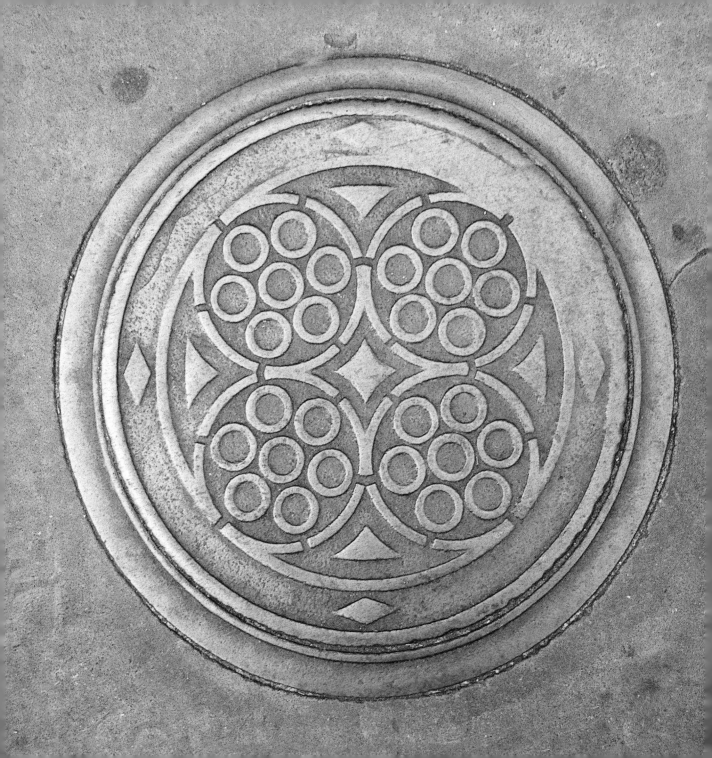

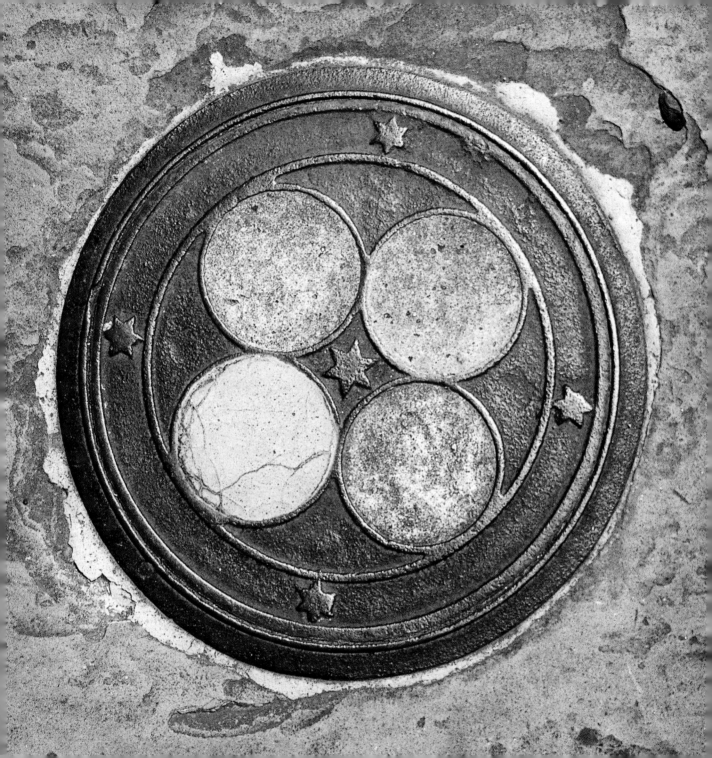

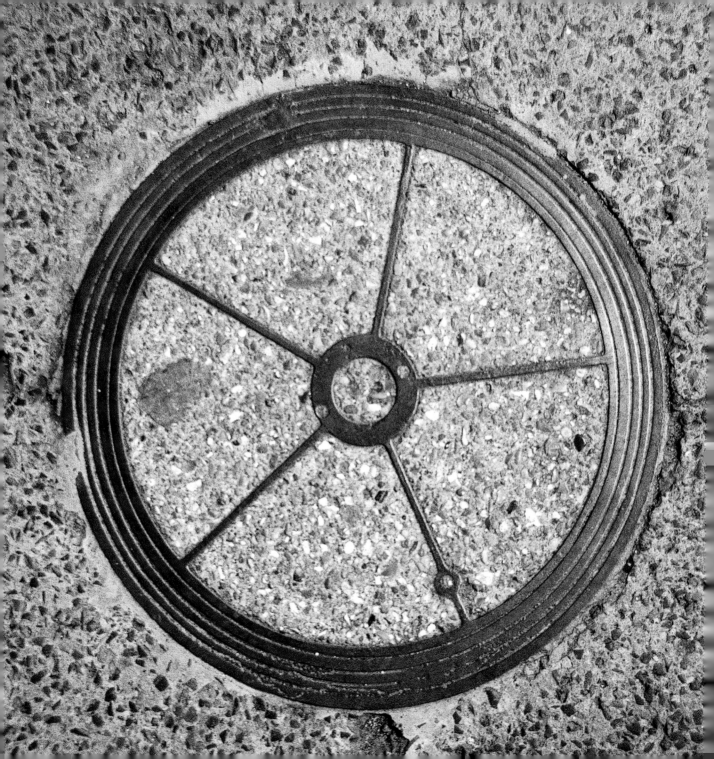

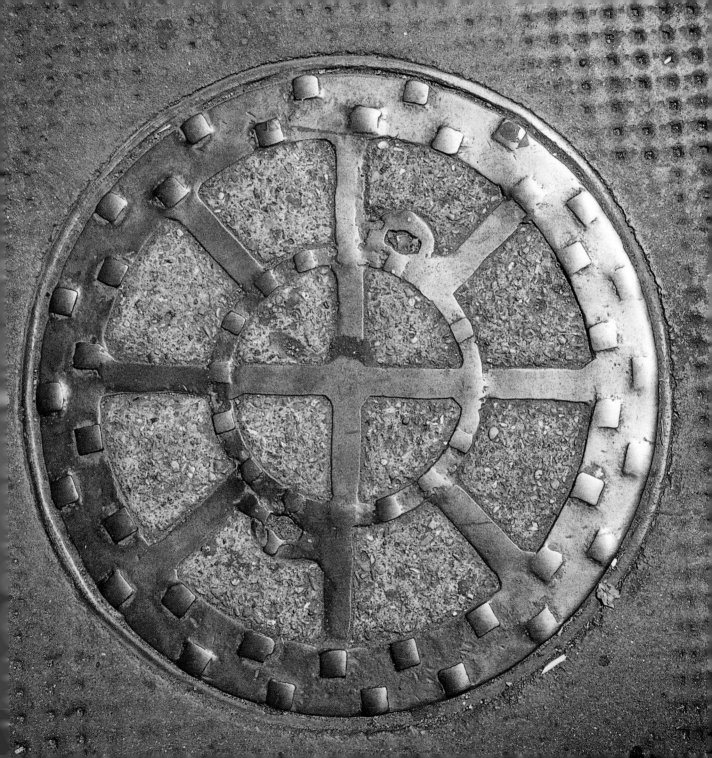

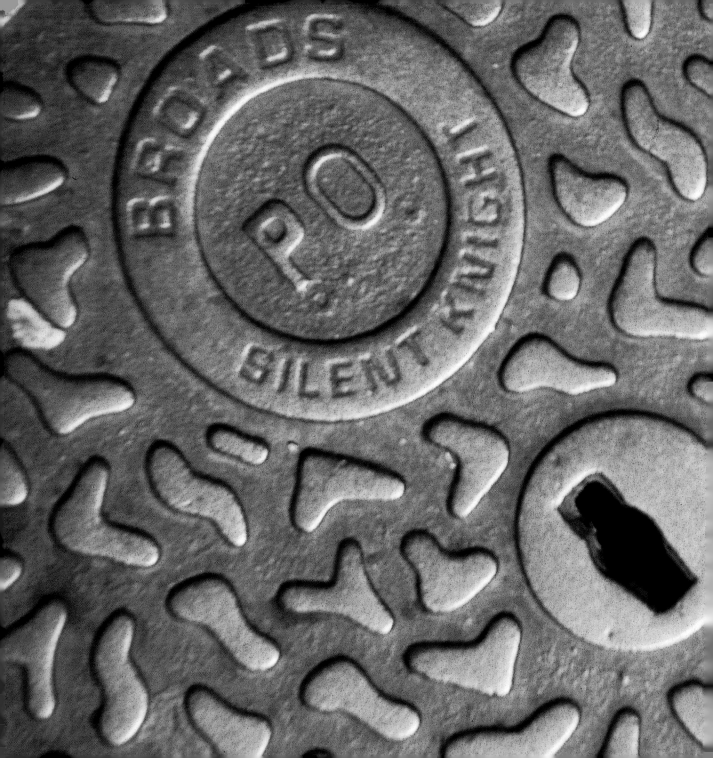

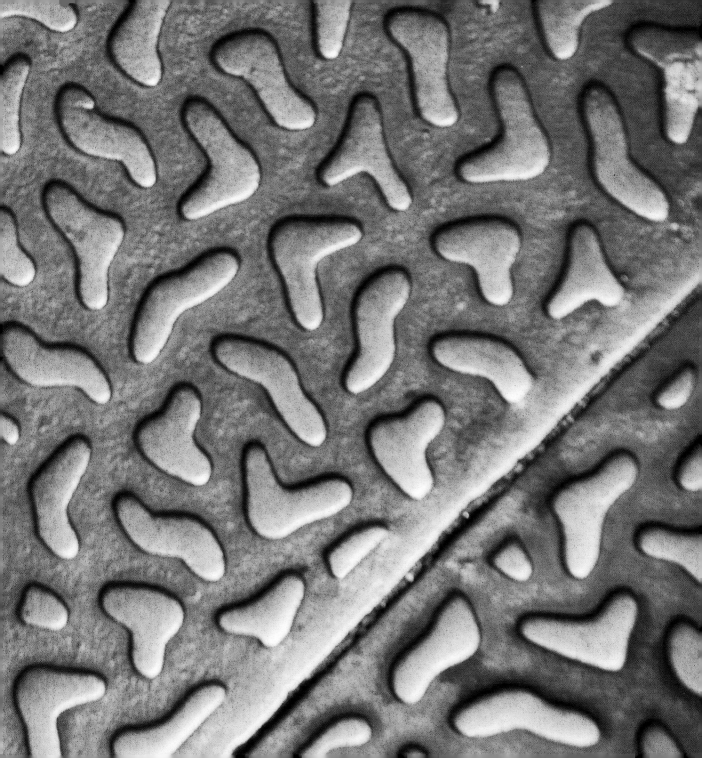

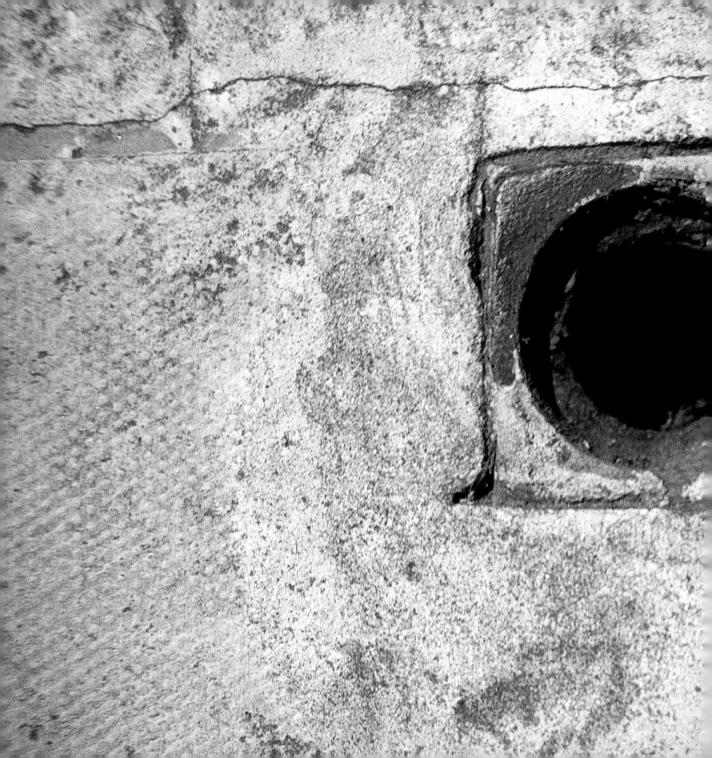

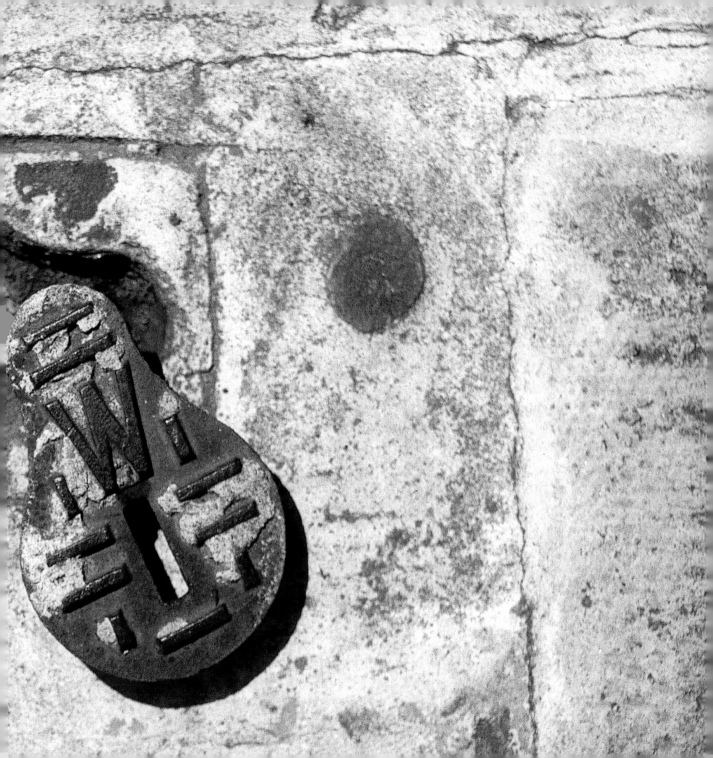

HAM BAK

MWB

CJD

MAKERS WES

F

HYD

...ER & C. LTD

...RE ✴

...RANT

...MINSTER SW

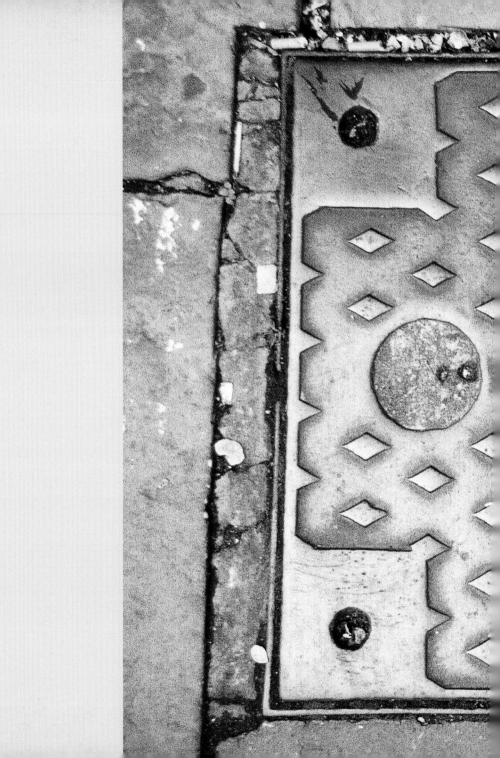

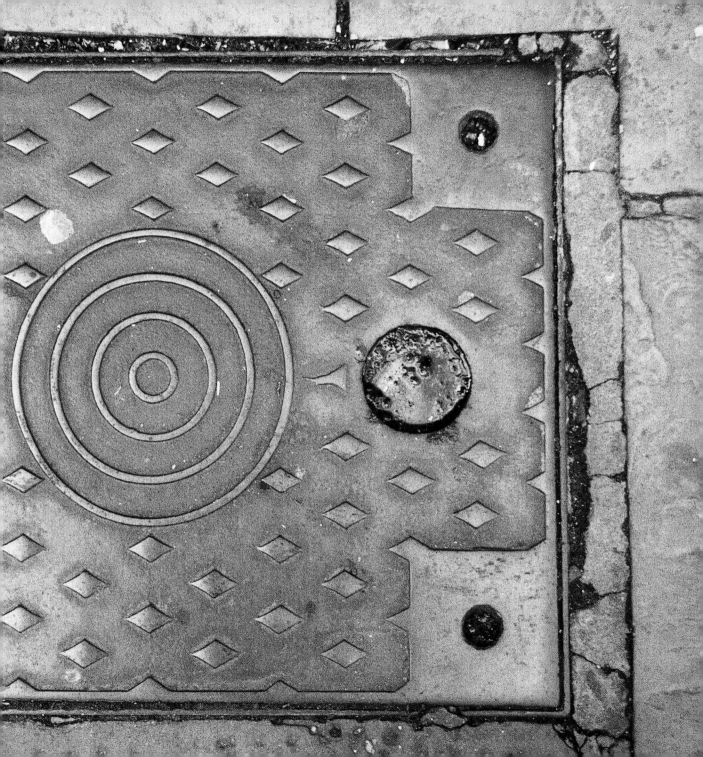

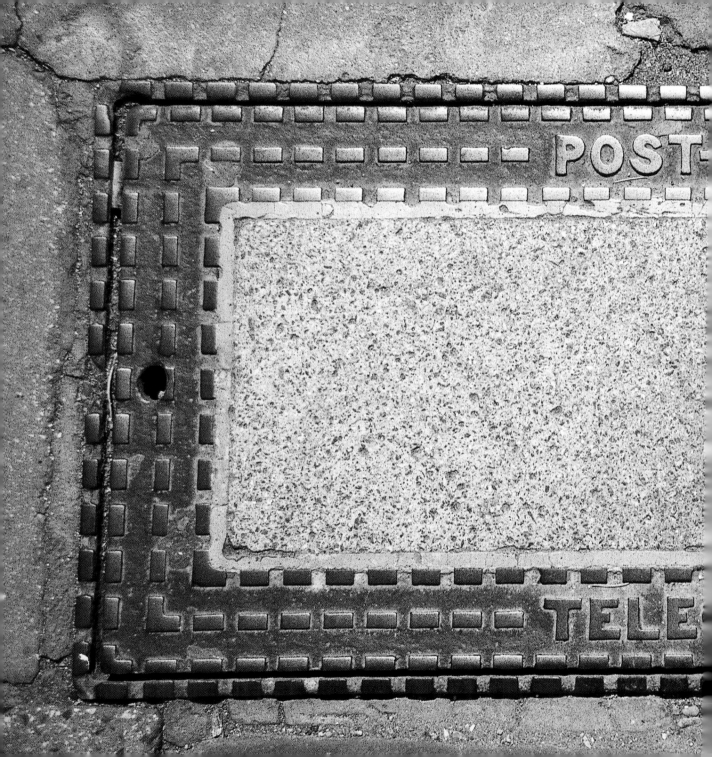

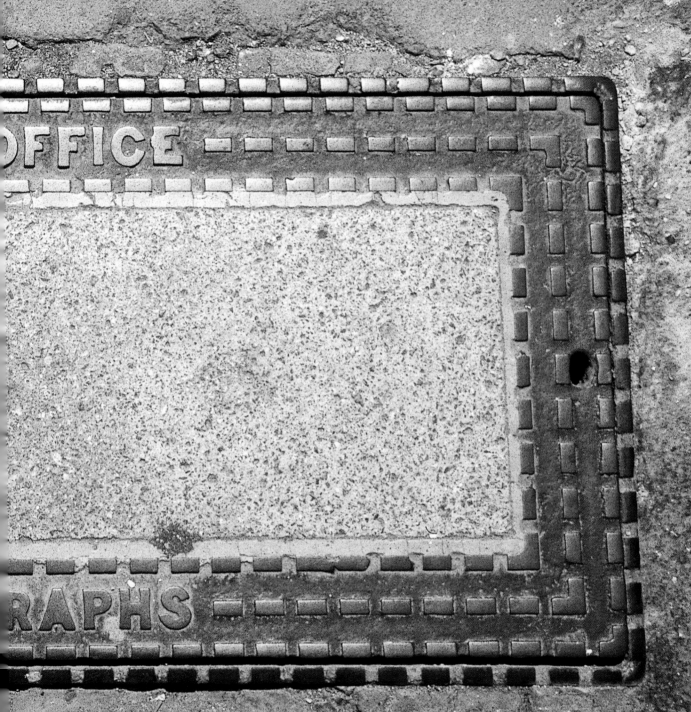

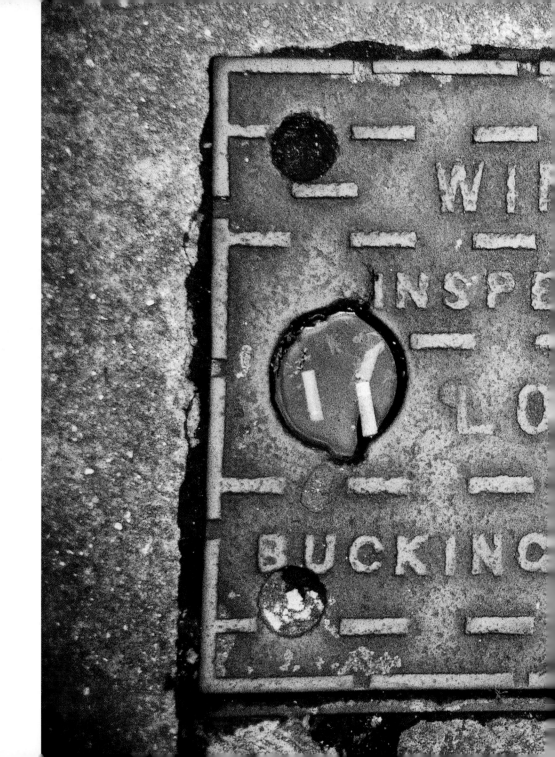

SER & Cº

CTION COVER

NDON S.W.

AM PALACE RD

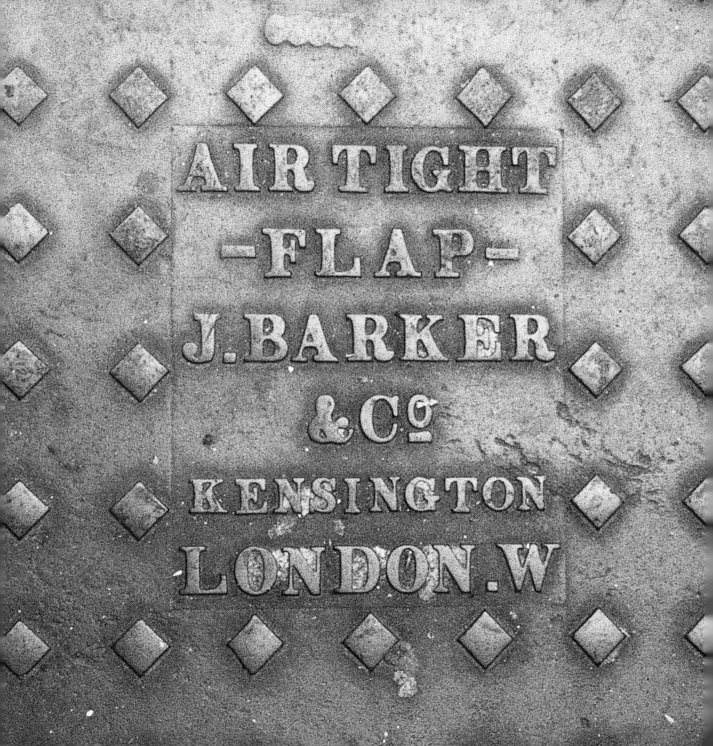

B. COLLEY & SONS

CLARENDON

WORKS

NOTTING HILL

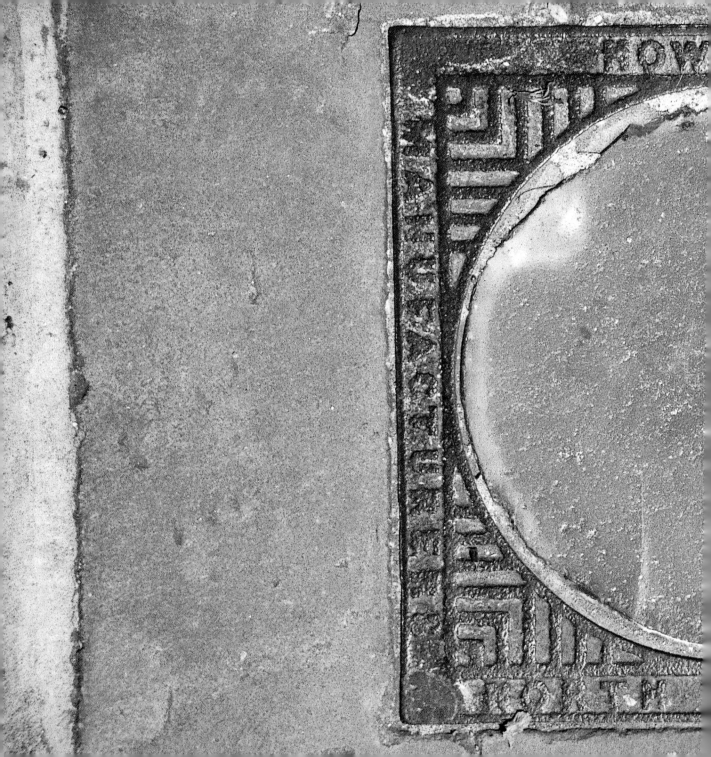

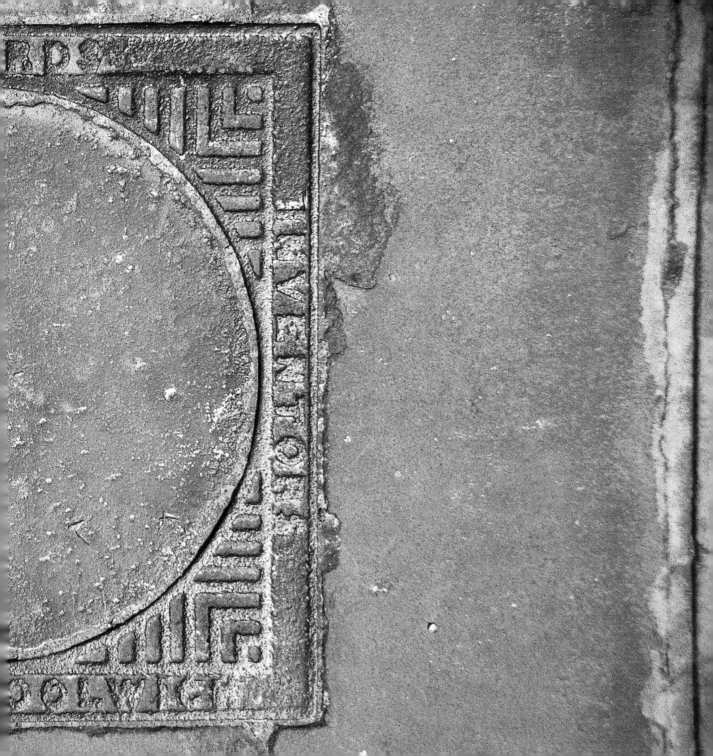

STANTON PLC
WARRIOR

Thames
Water

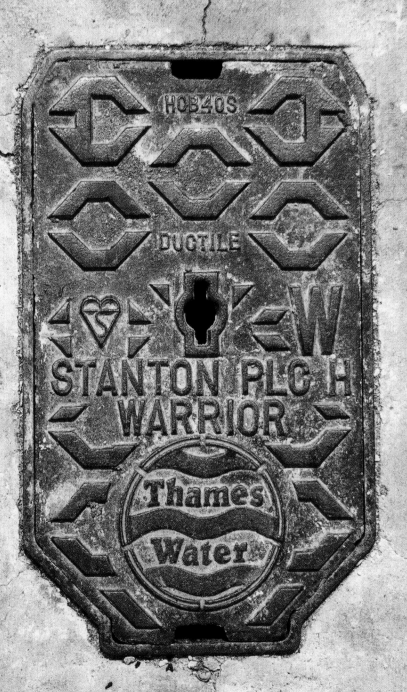

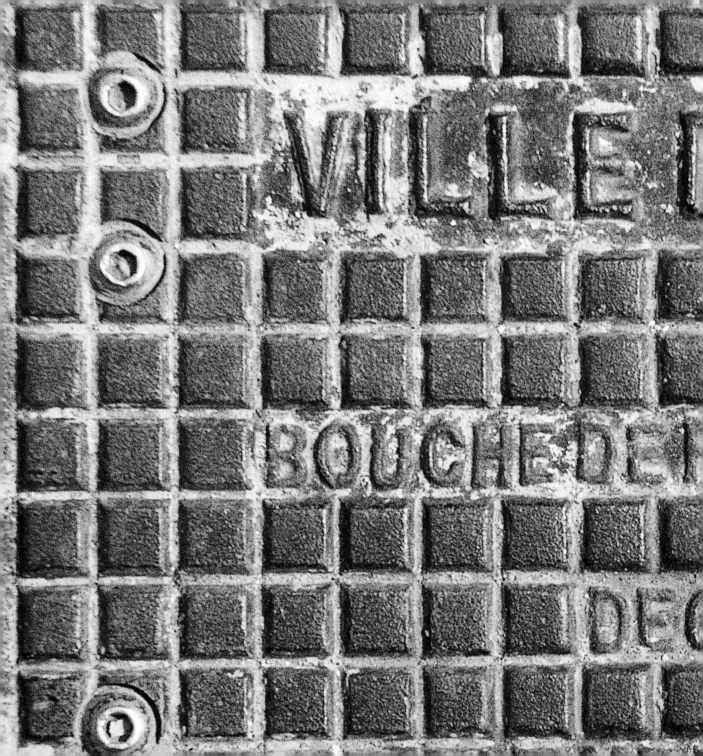

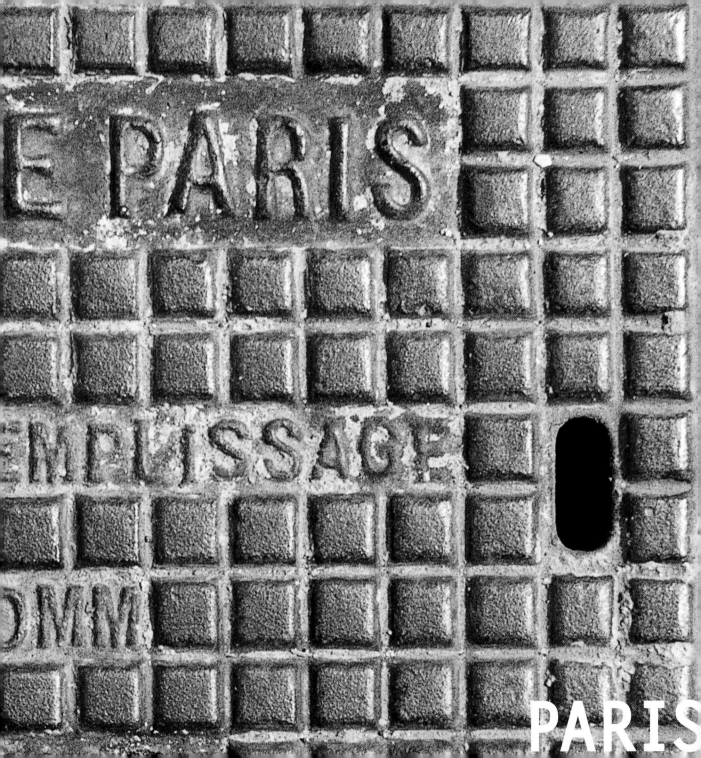

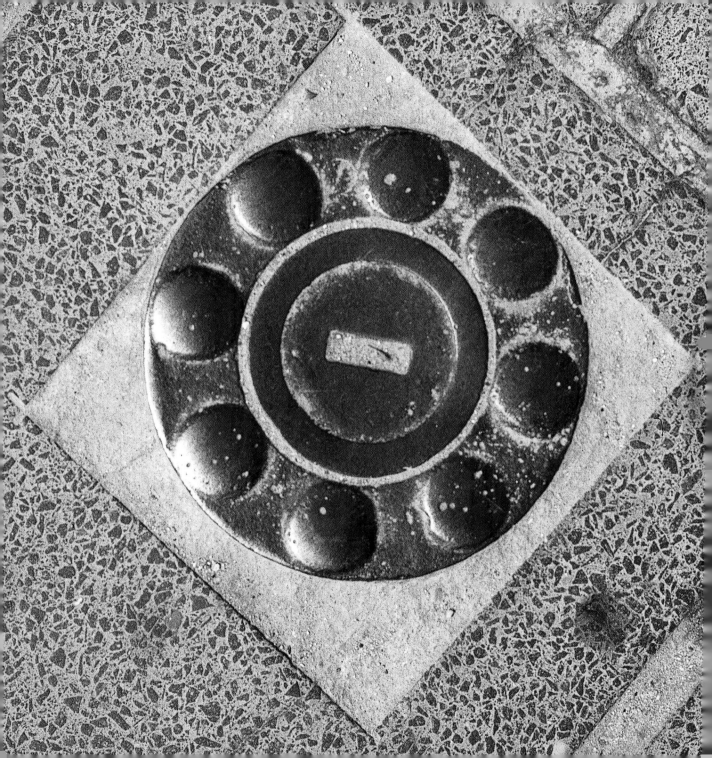

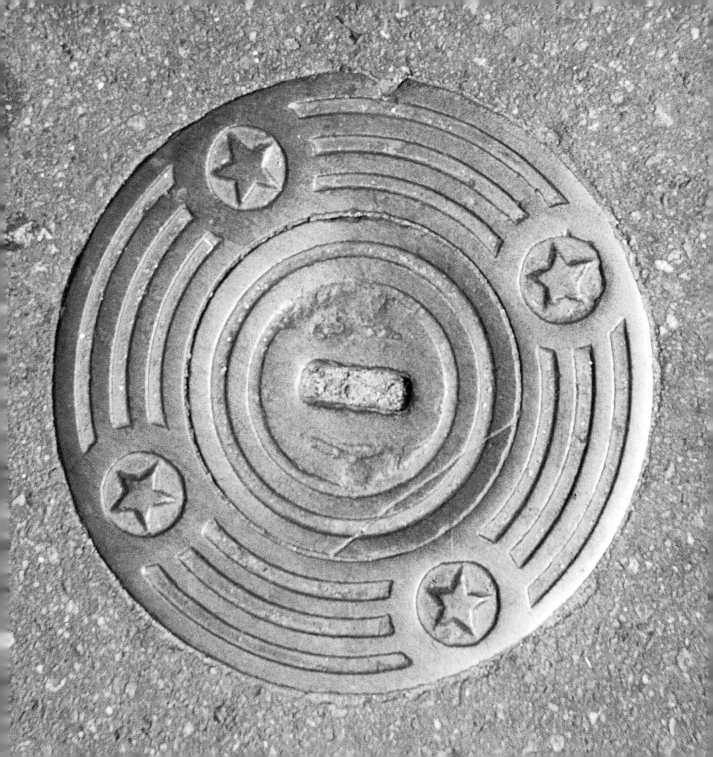

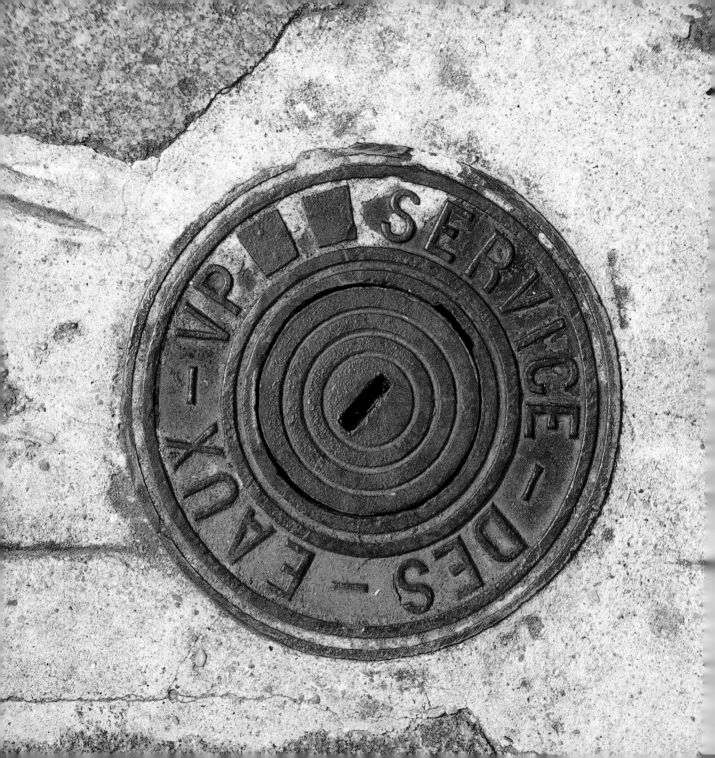

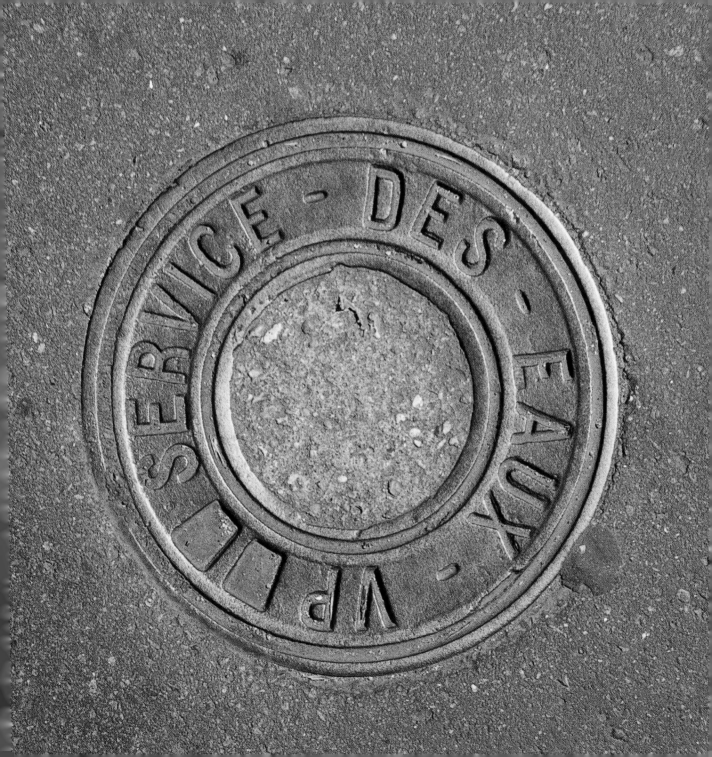

GAZ

EN 124 C 250

F

O

FONDERIES L'UNION

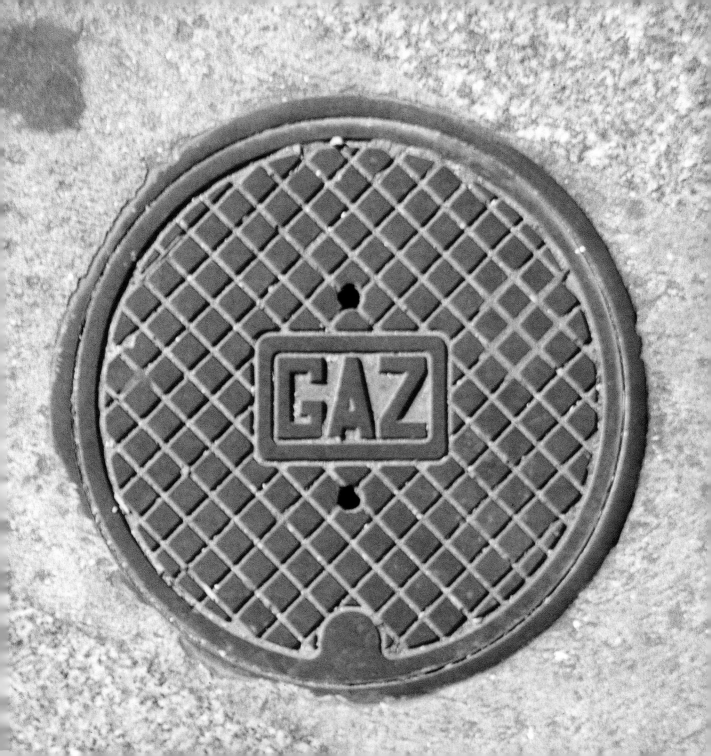

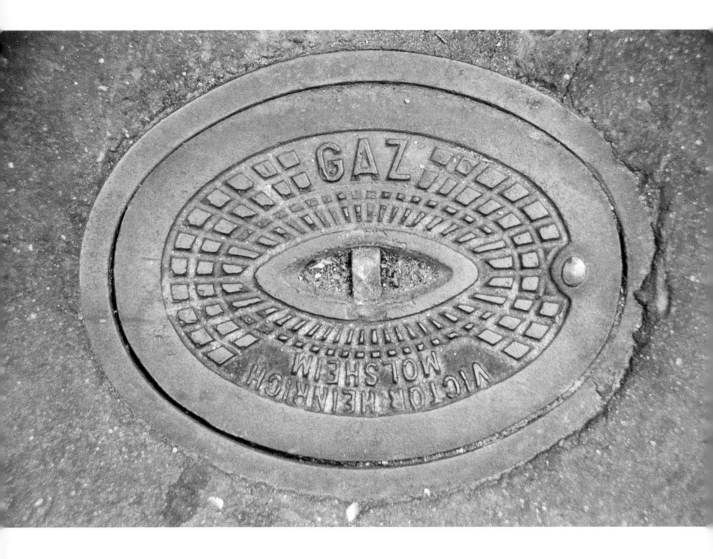

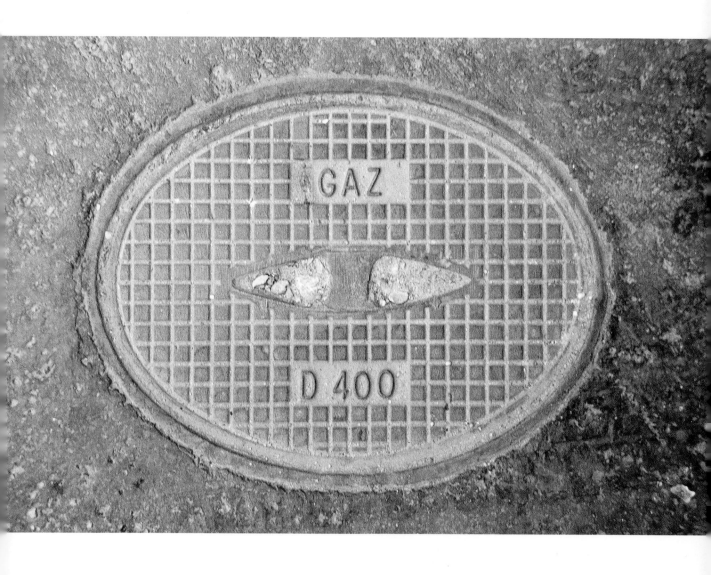

ELECTRICITE

F.A.B.A.E

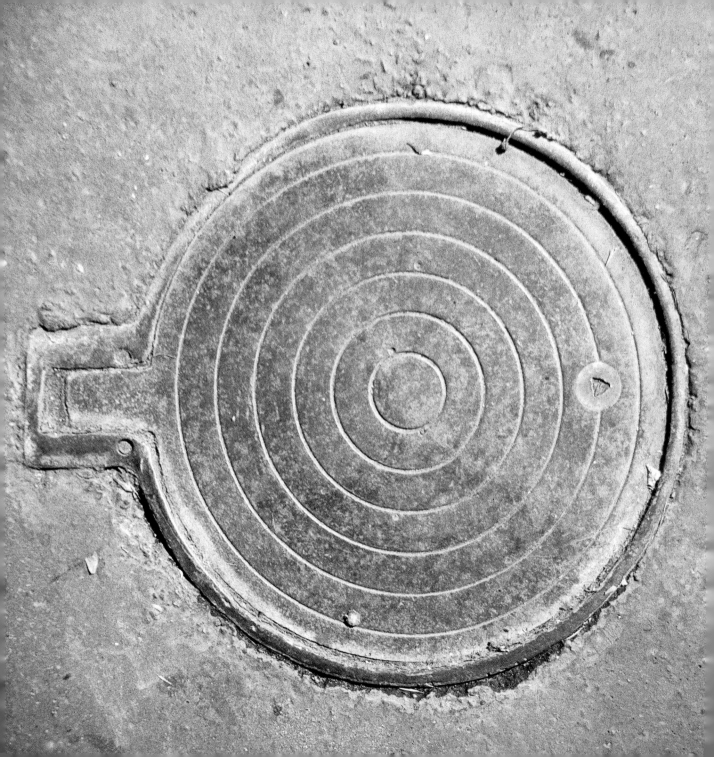

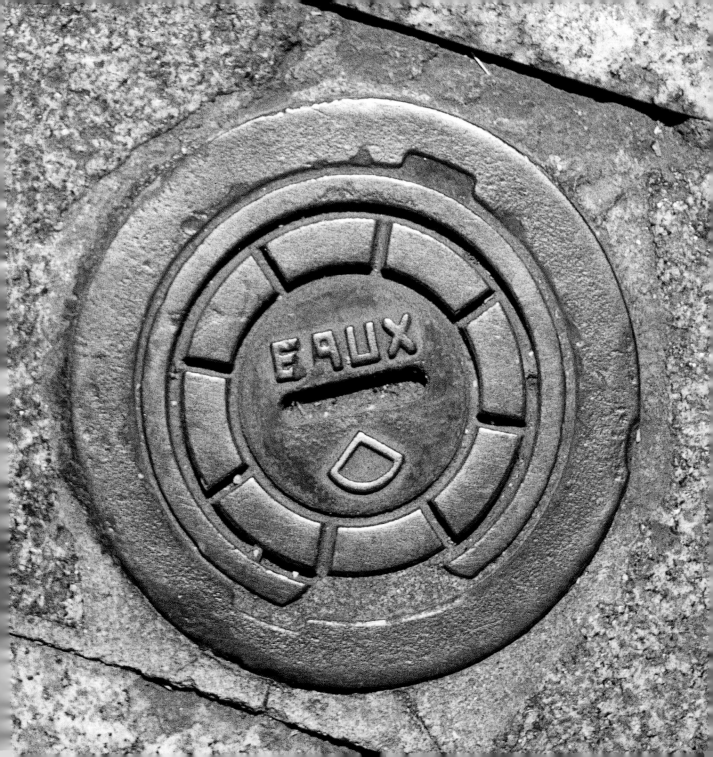

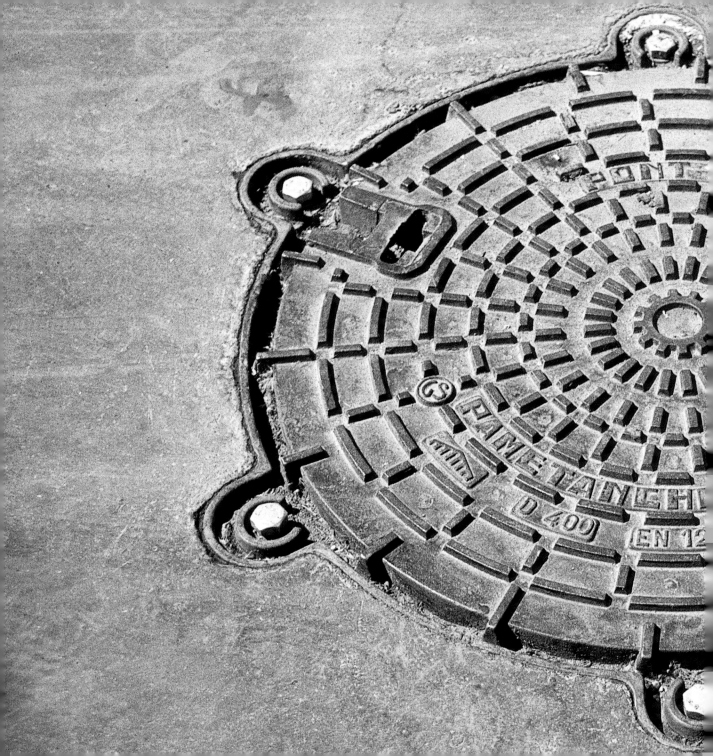

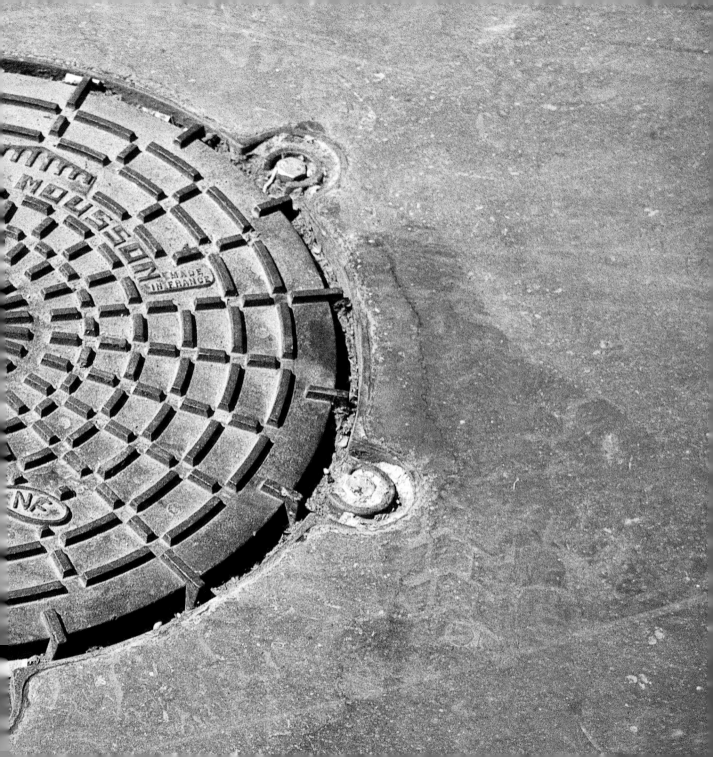

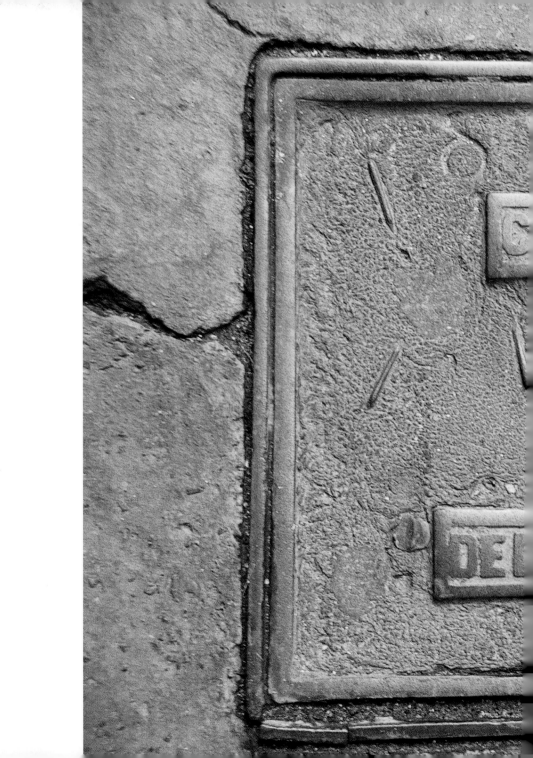

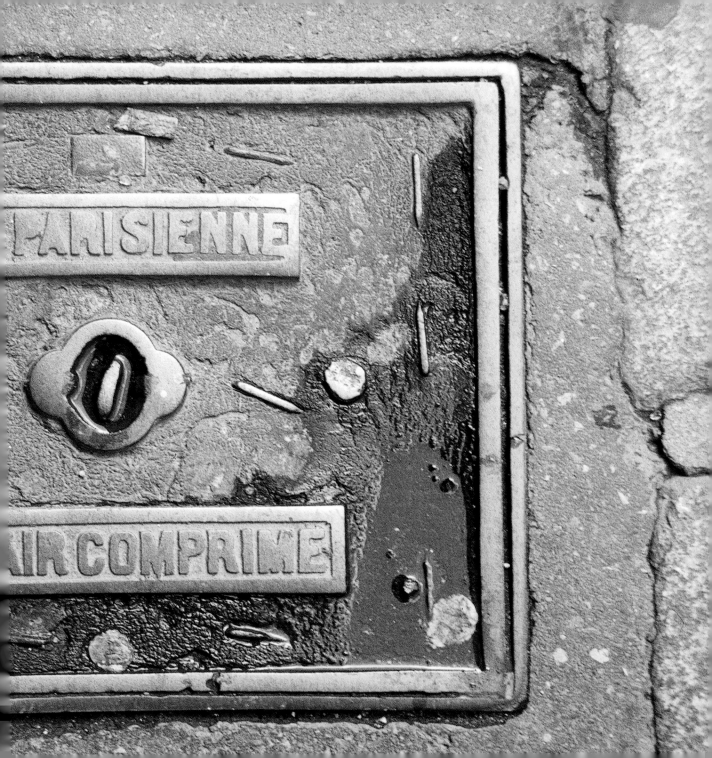

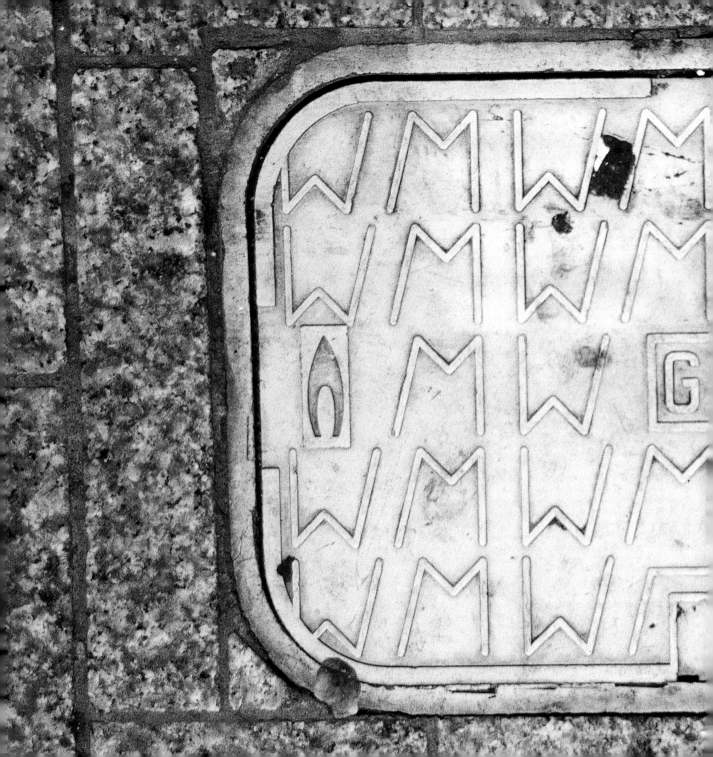

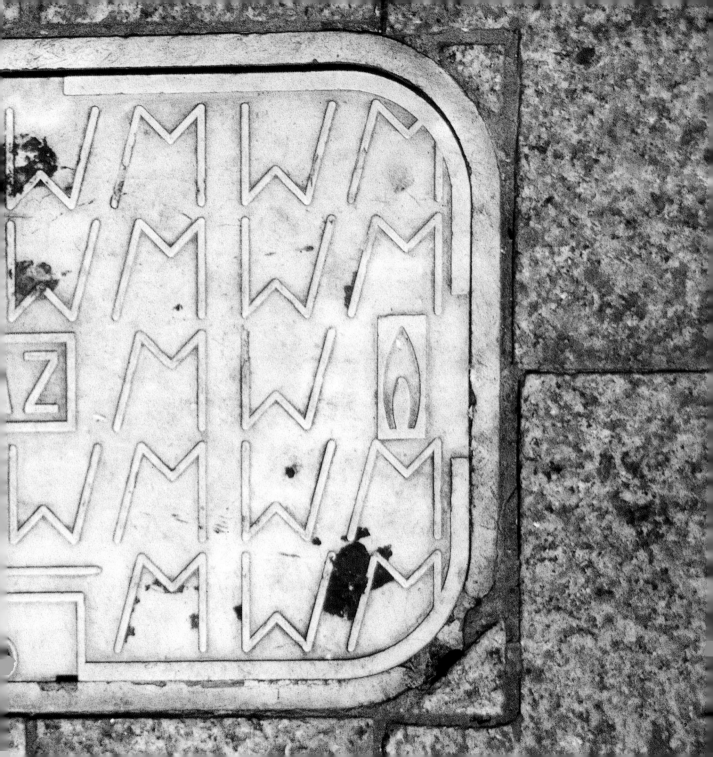

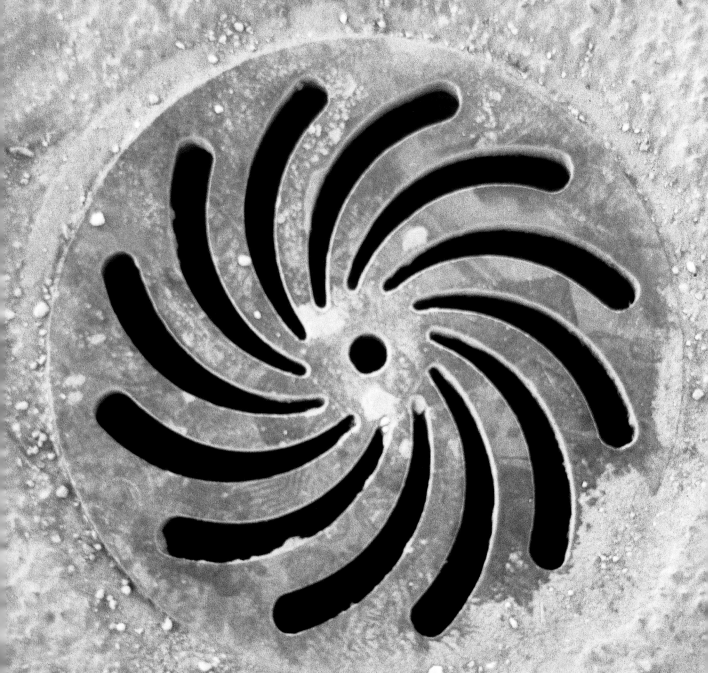

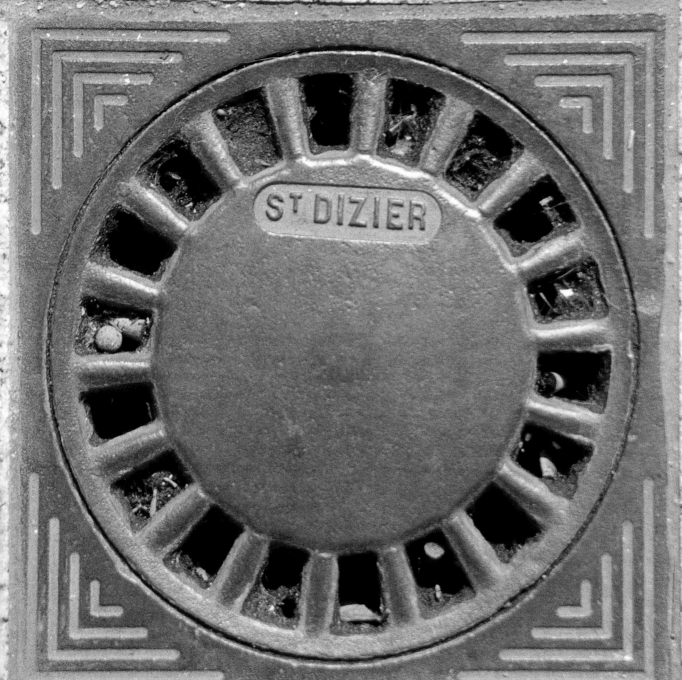

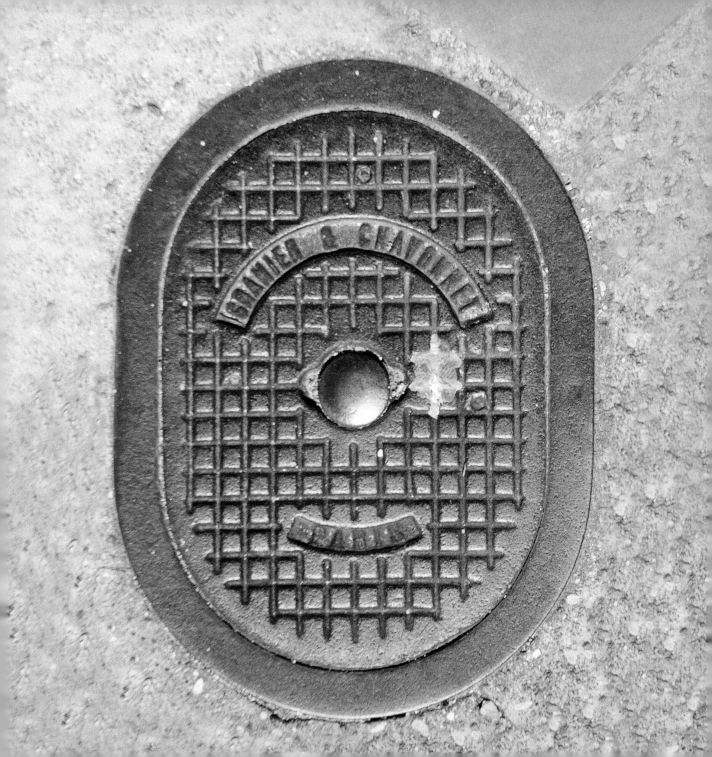

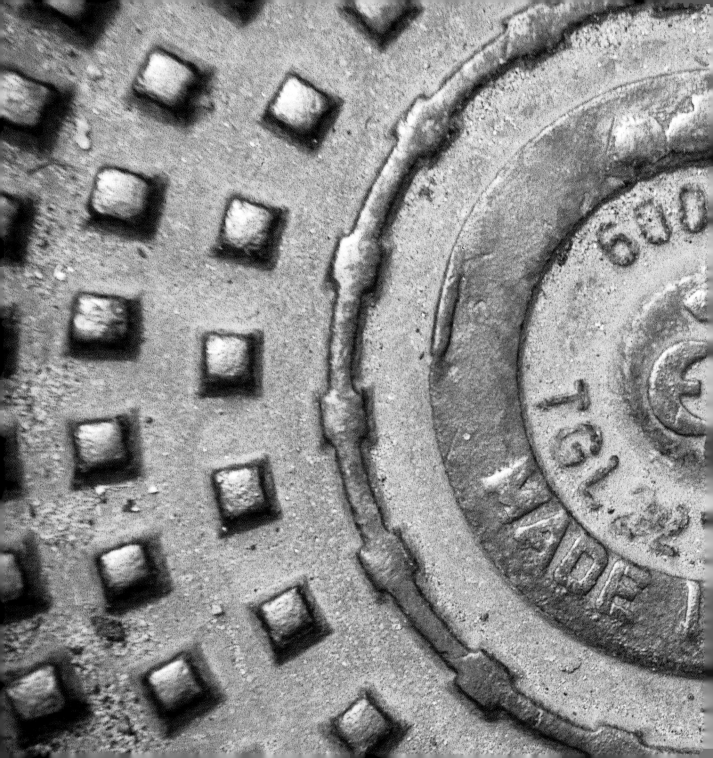

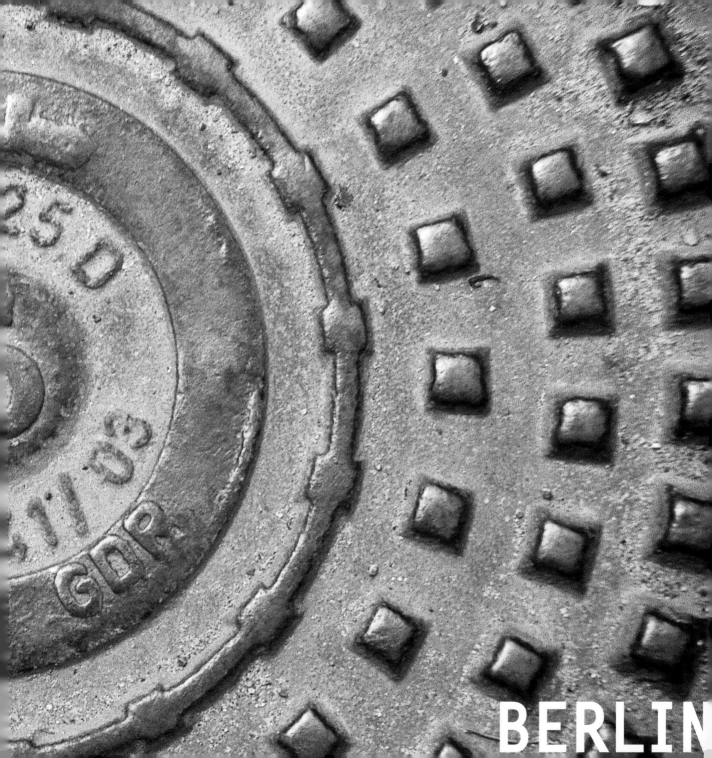
BERLIN

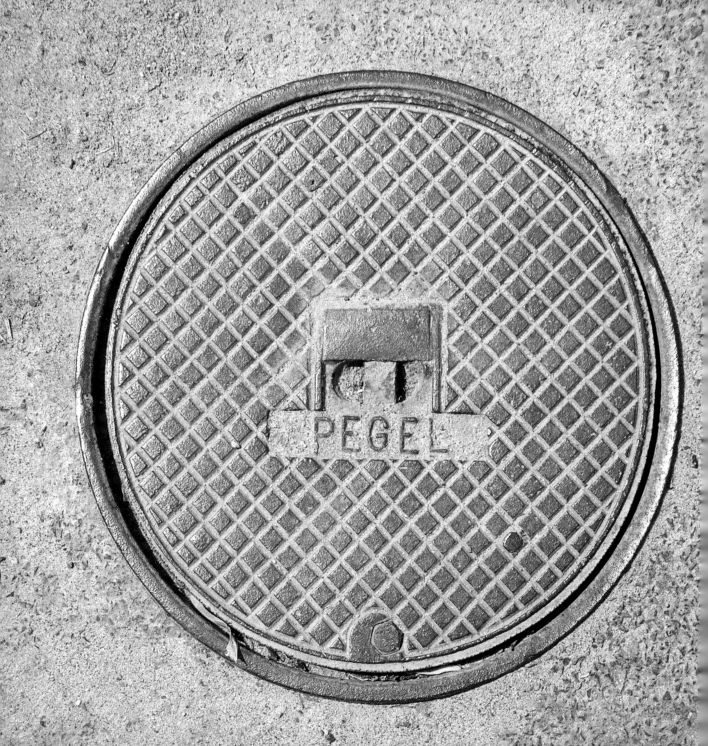

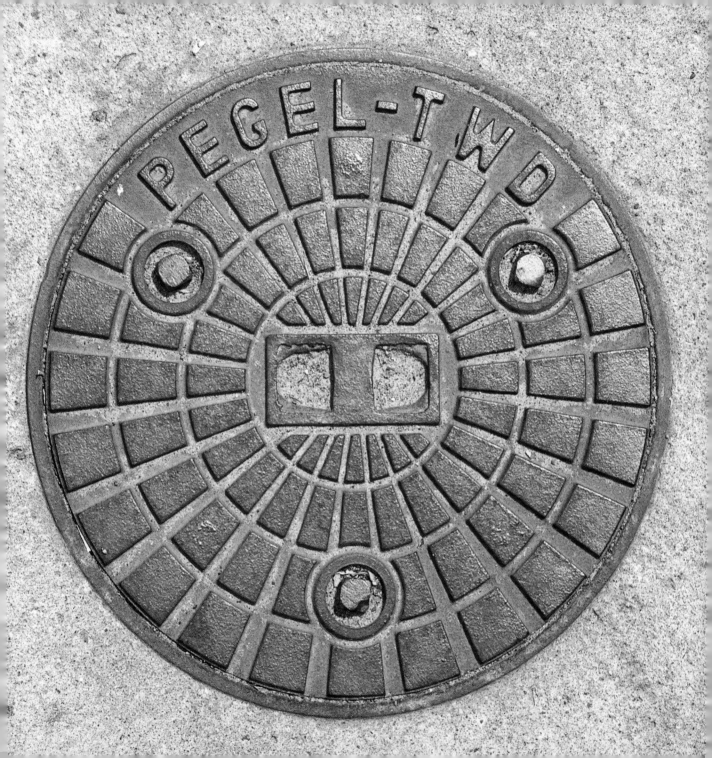

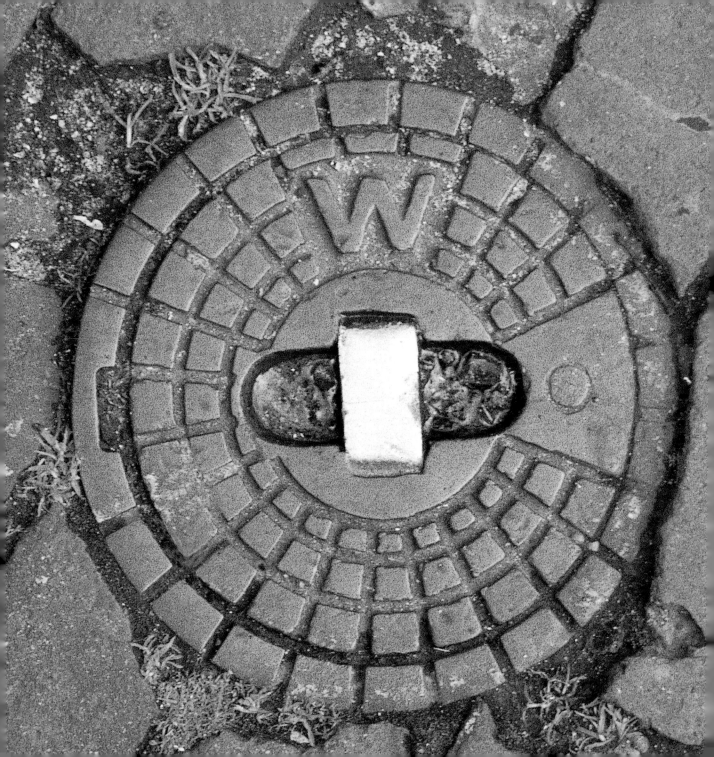

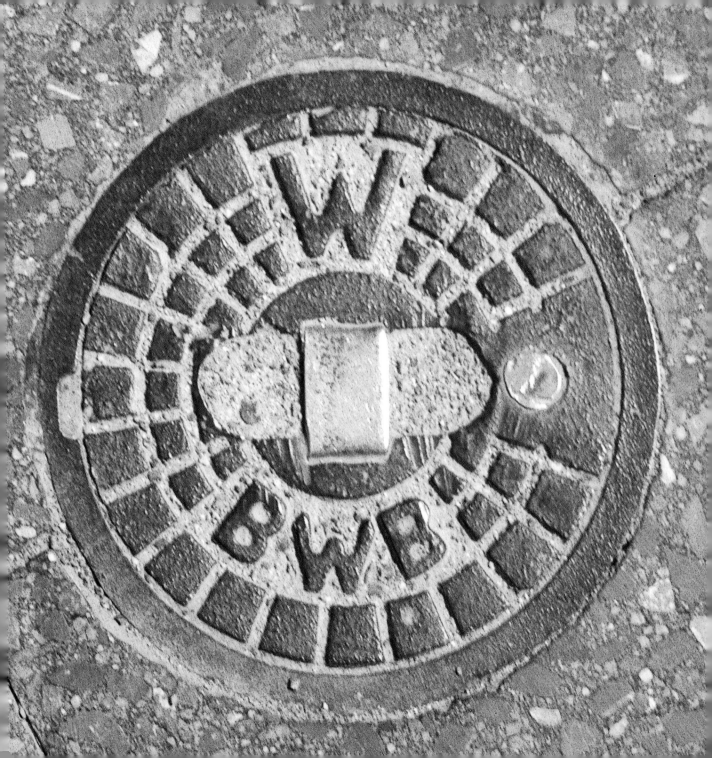

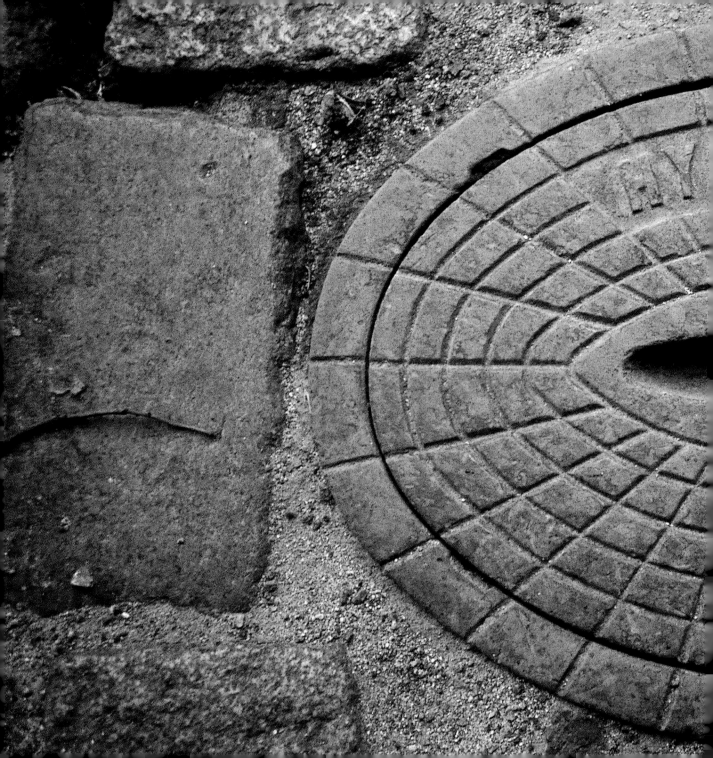

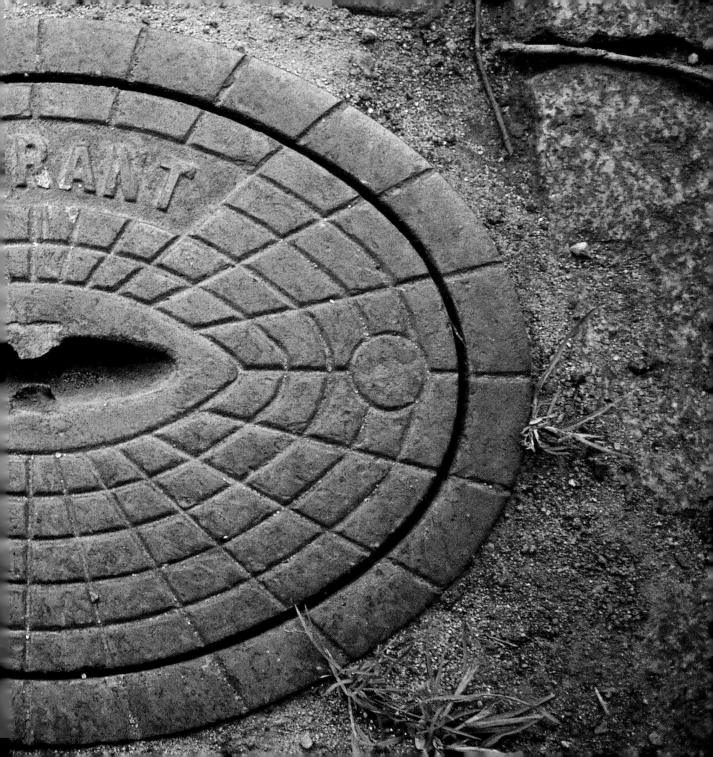

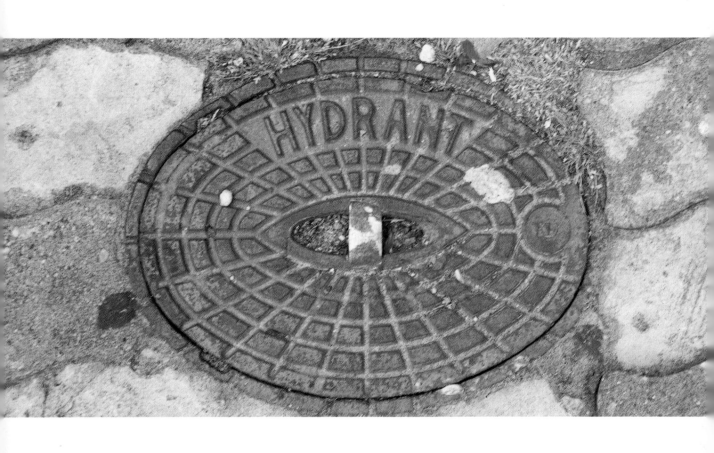

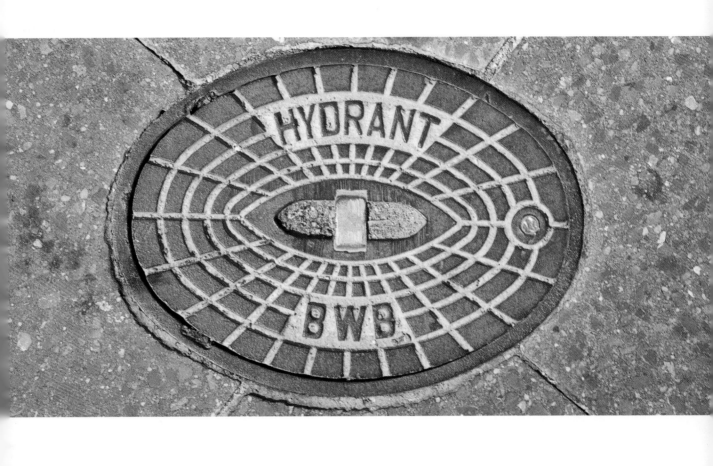

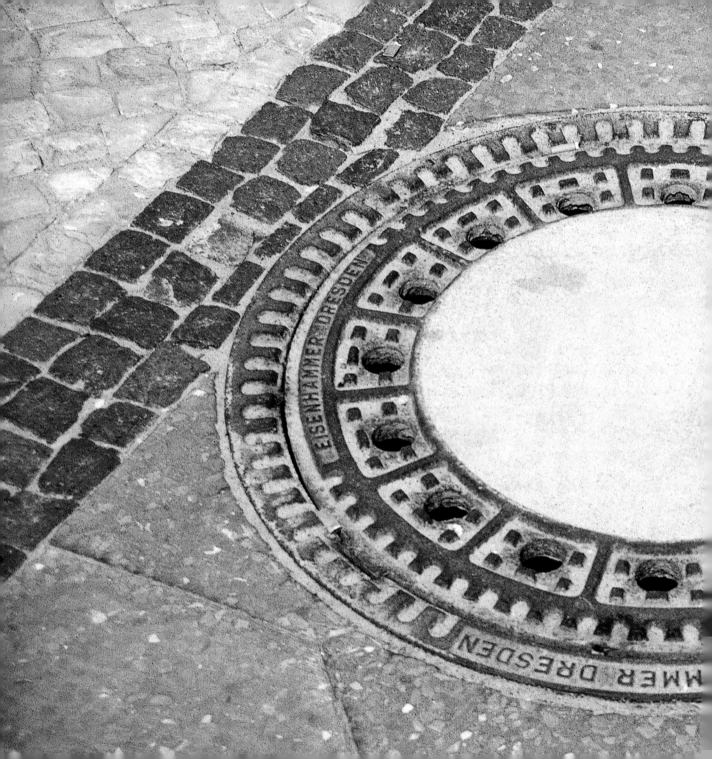

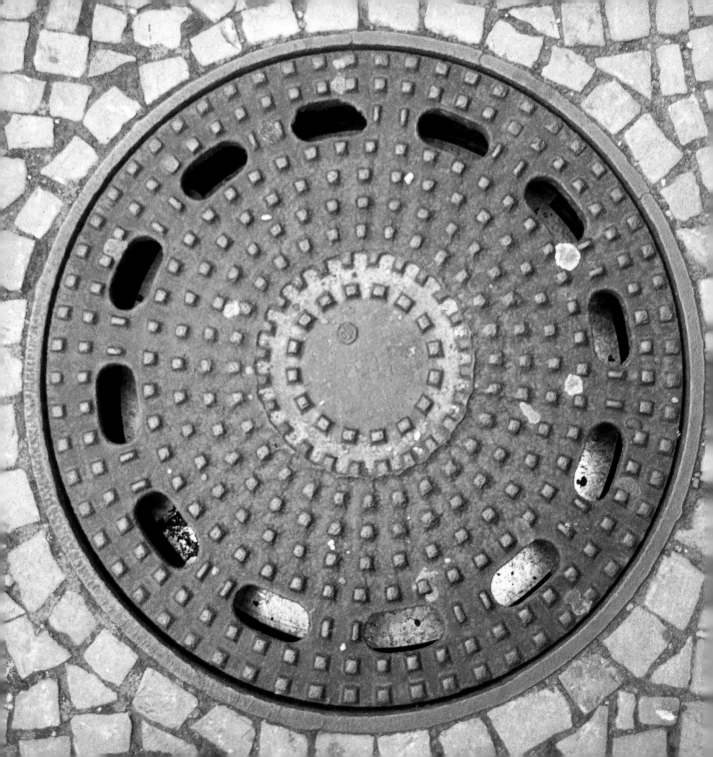

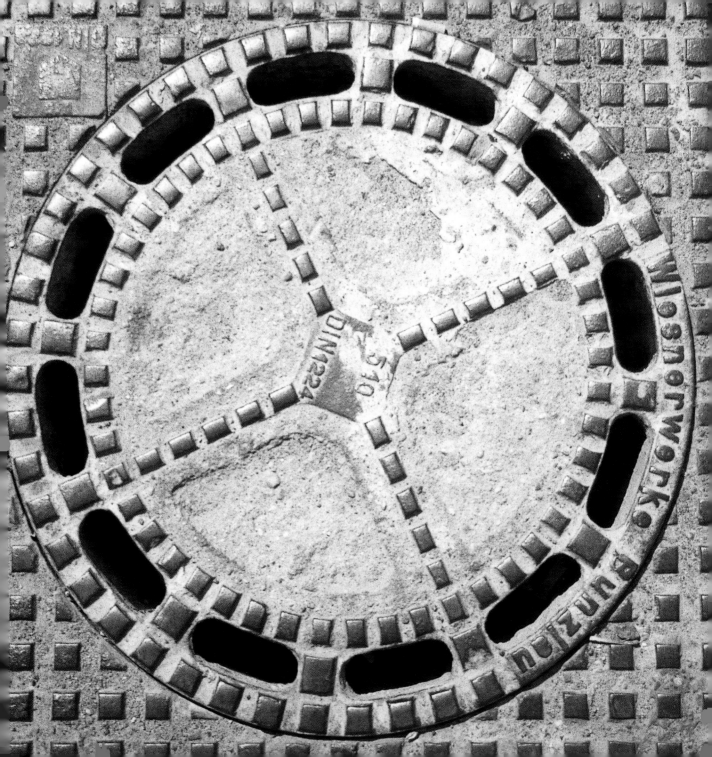

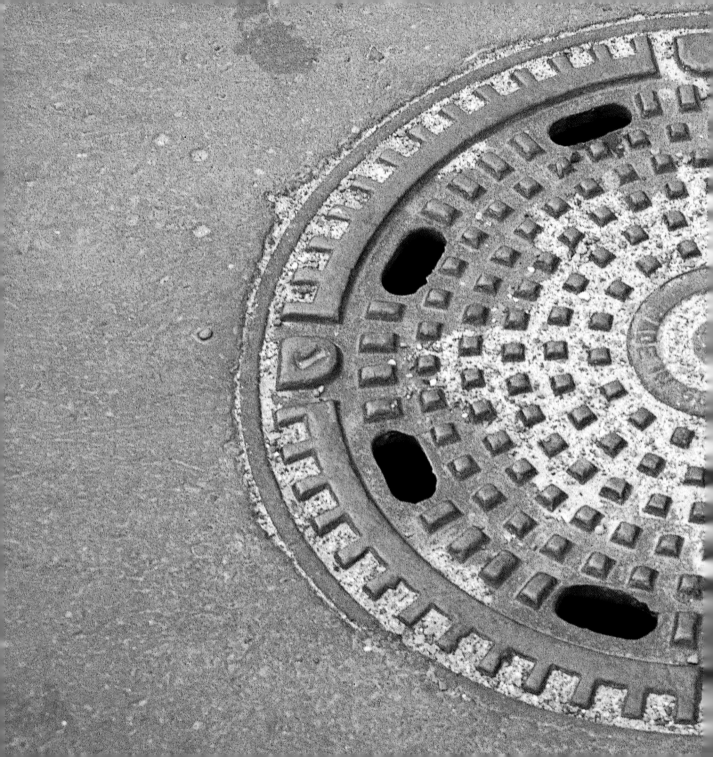

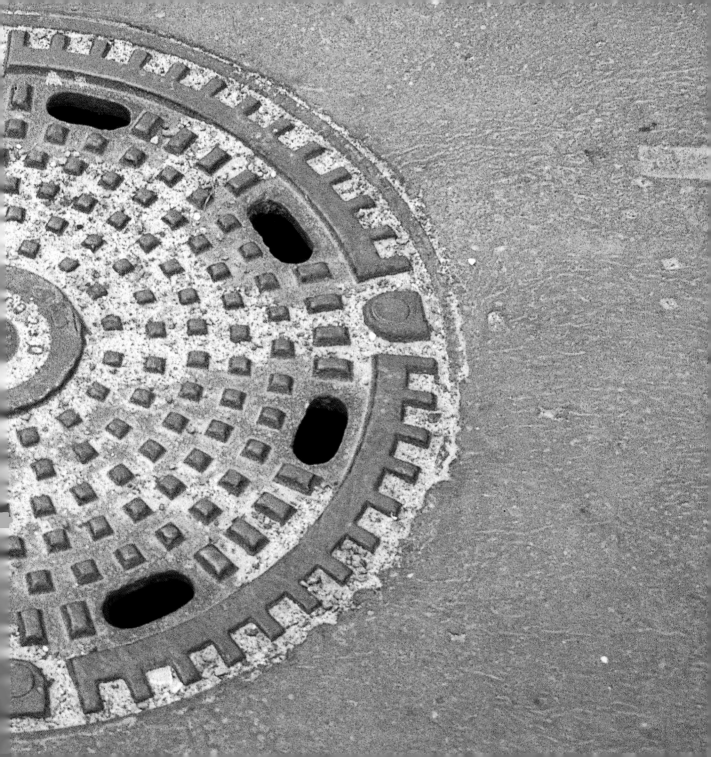

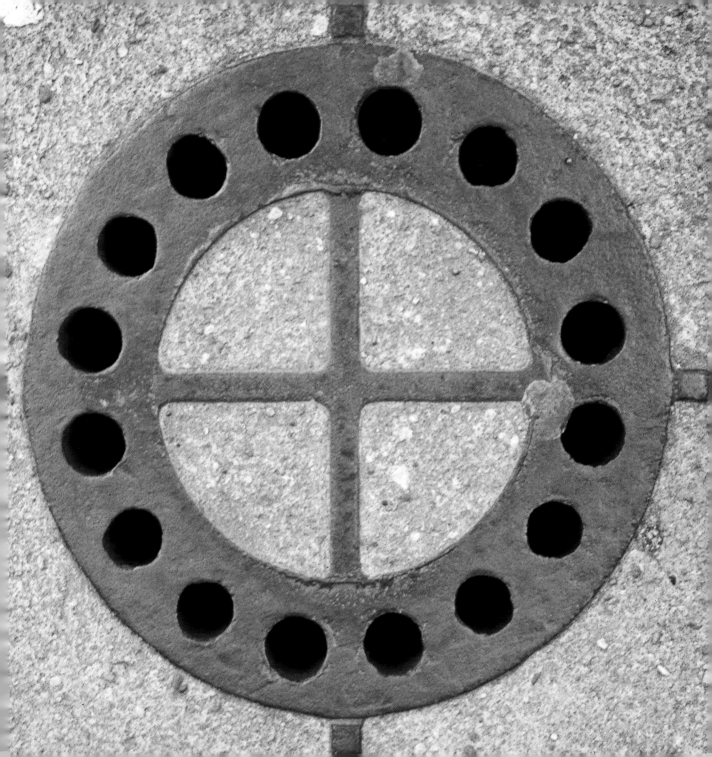

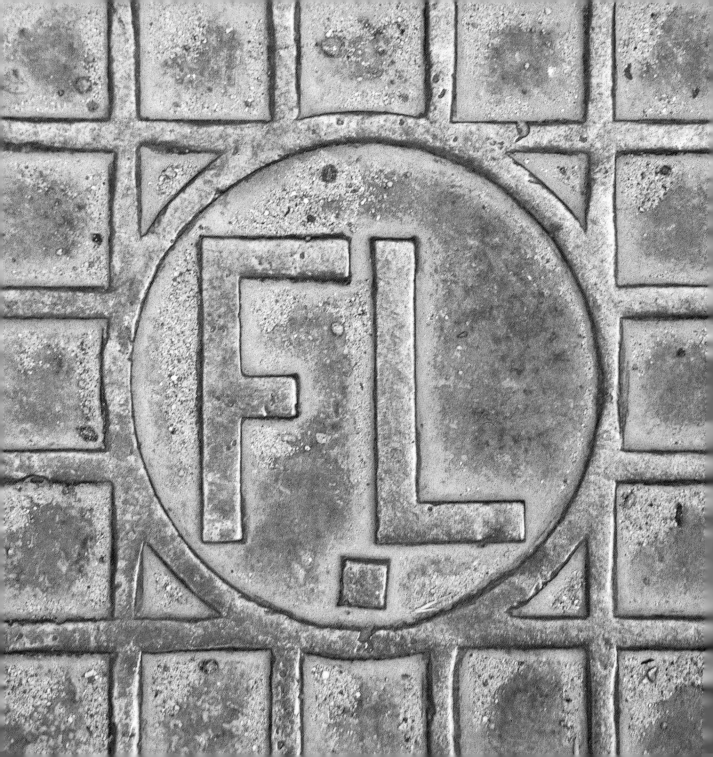

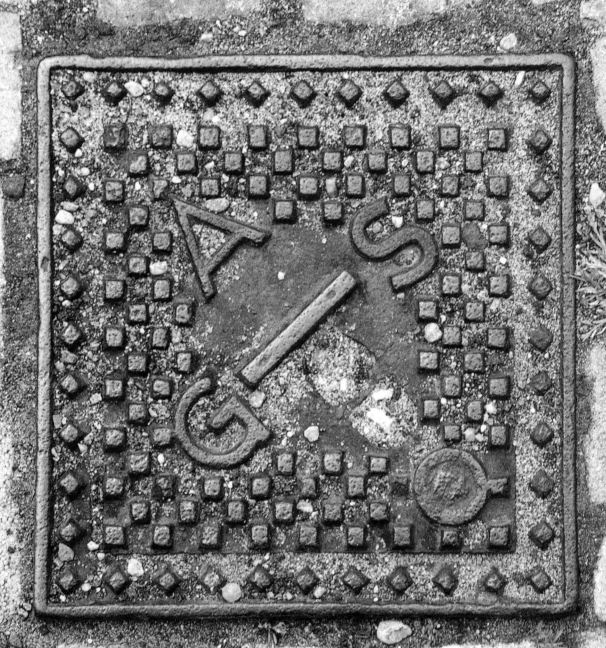

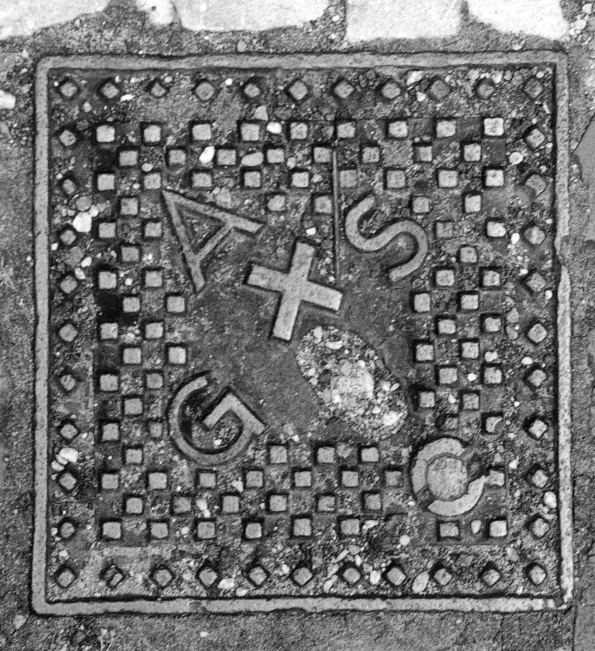

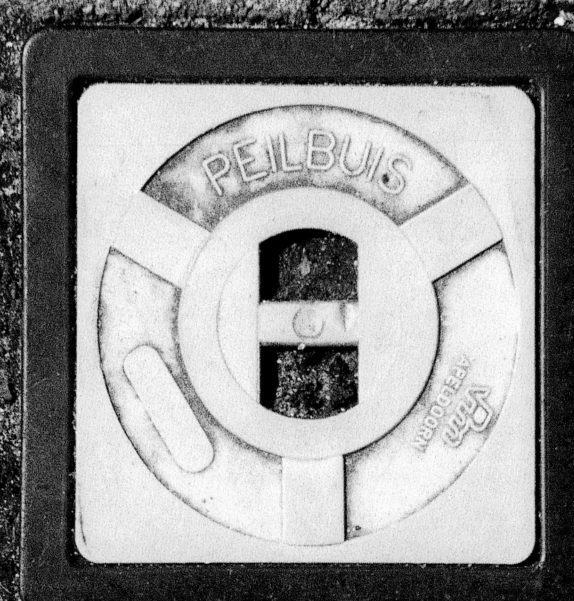

AMSTERDAM

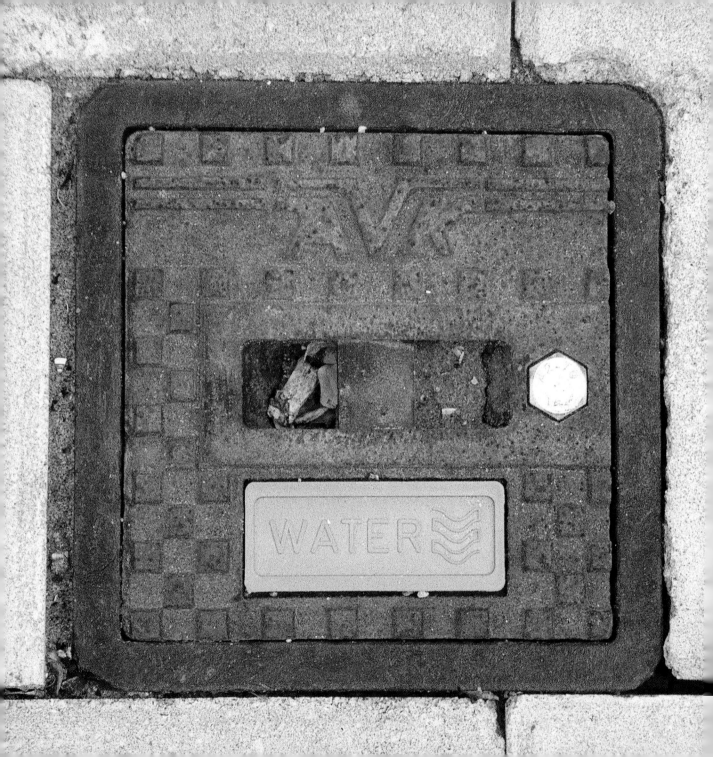

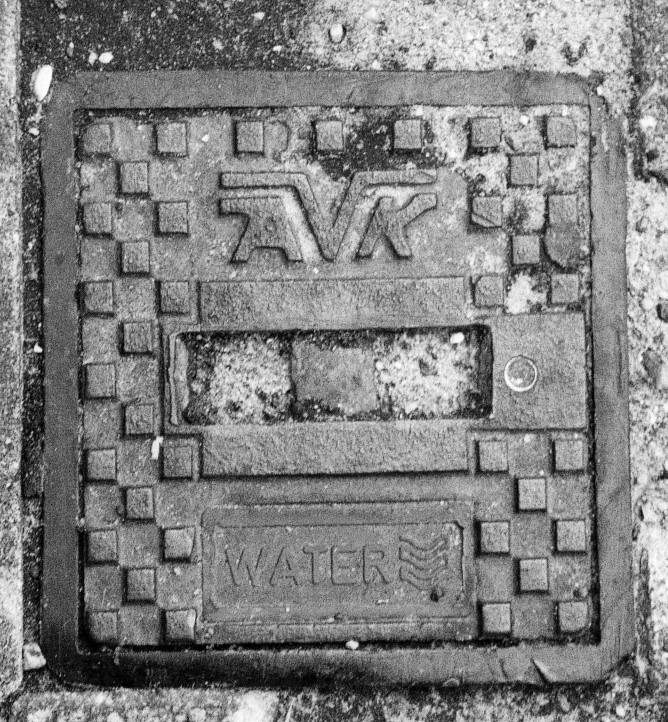

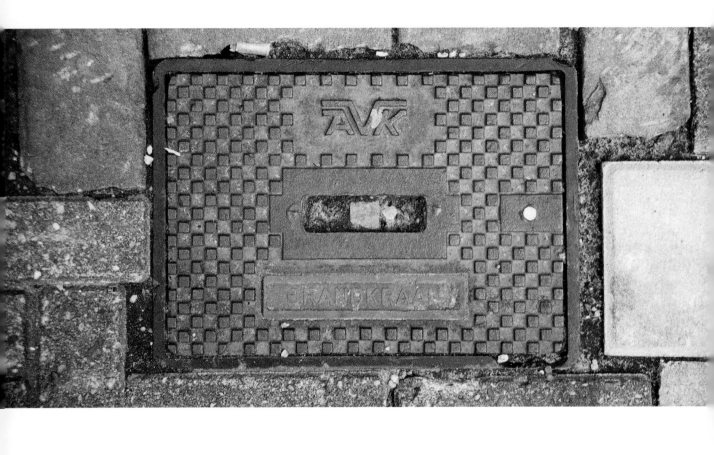

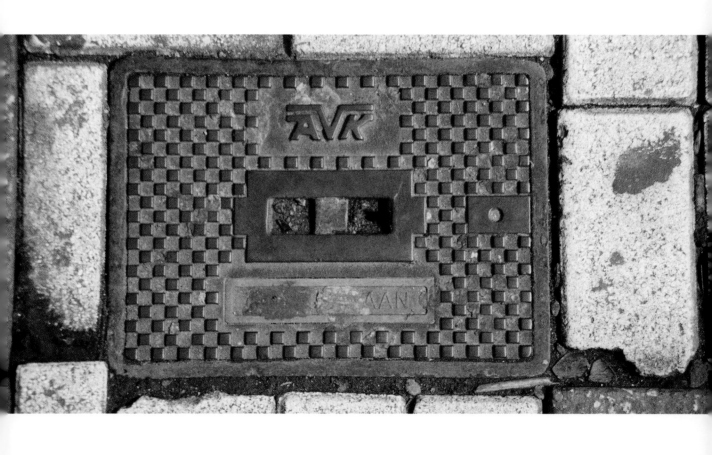

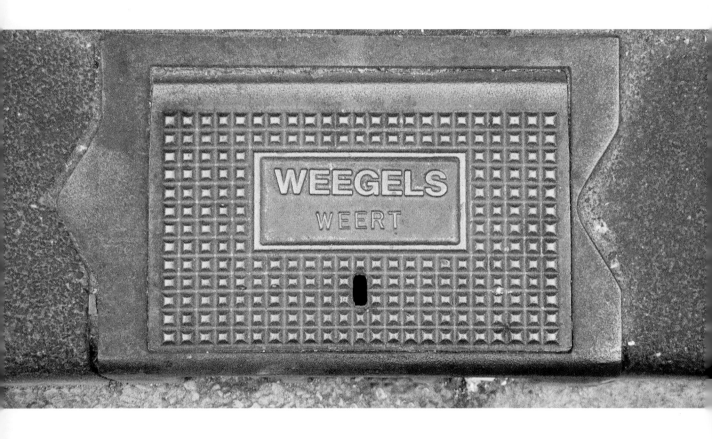

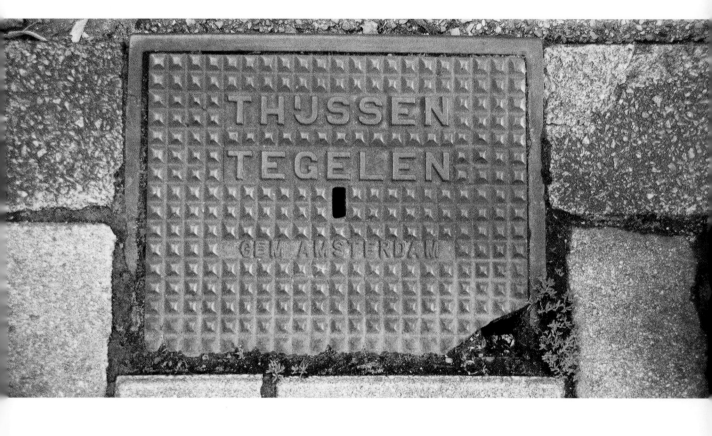

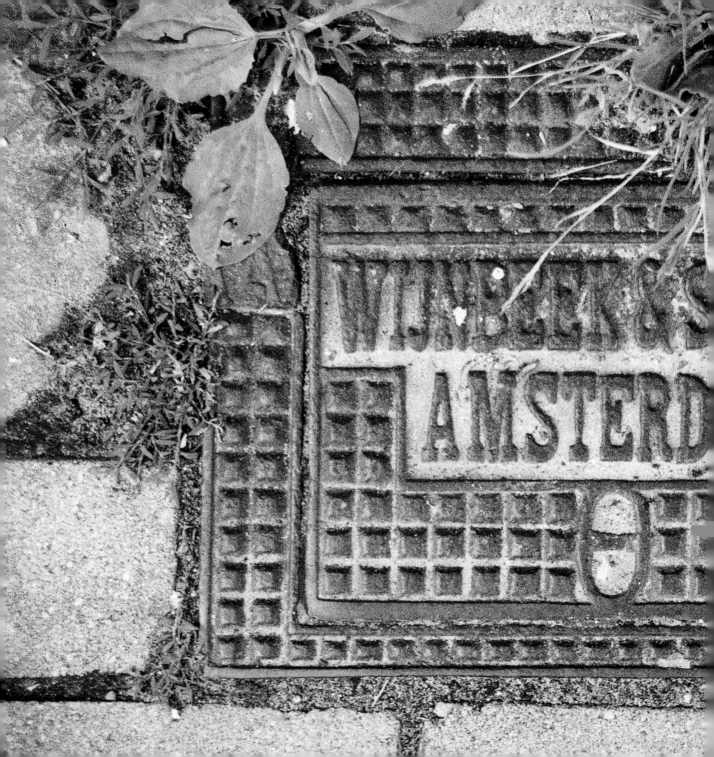

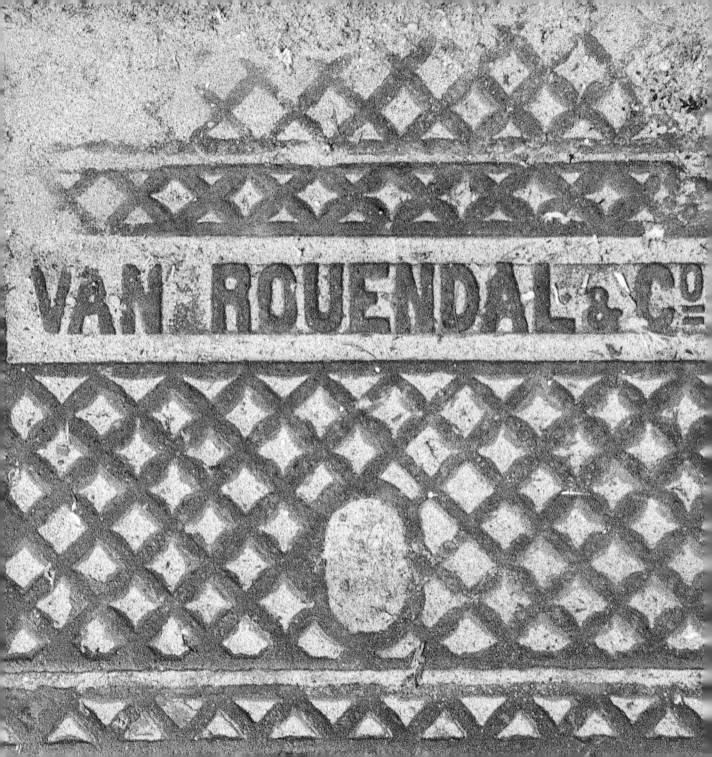

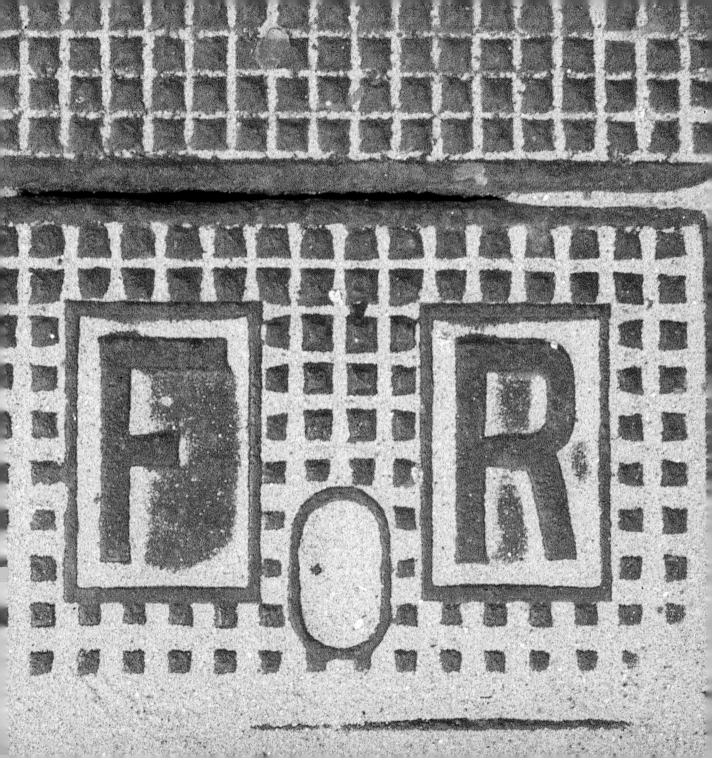

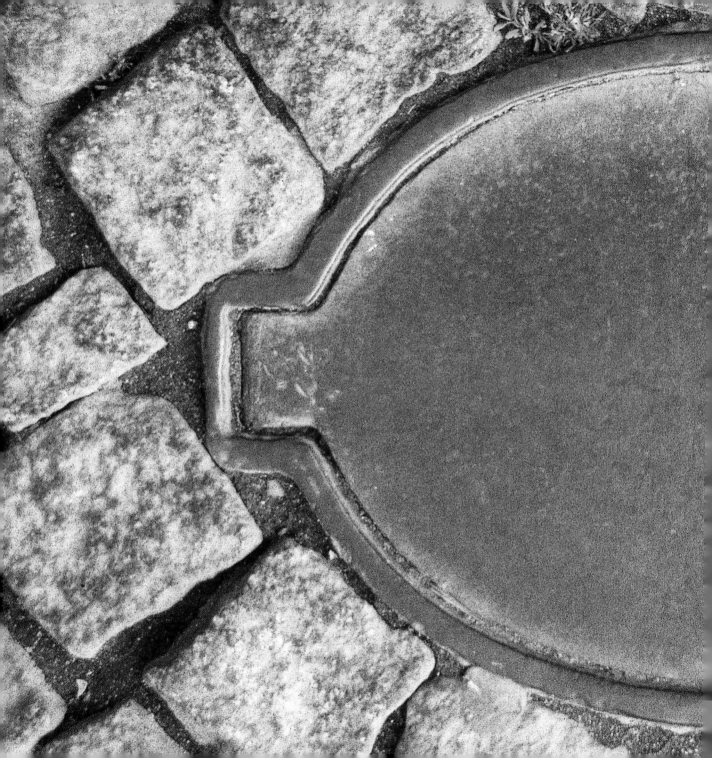

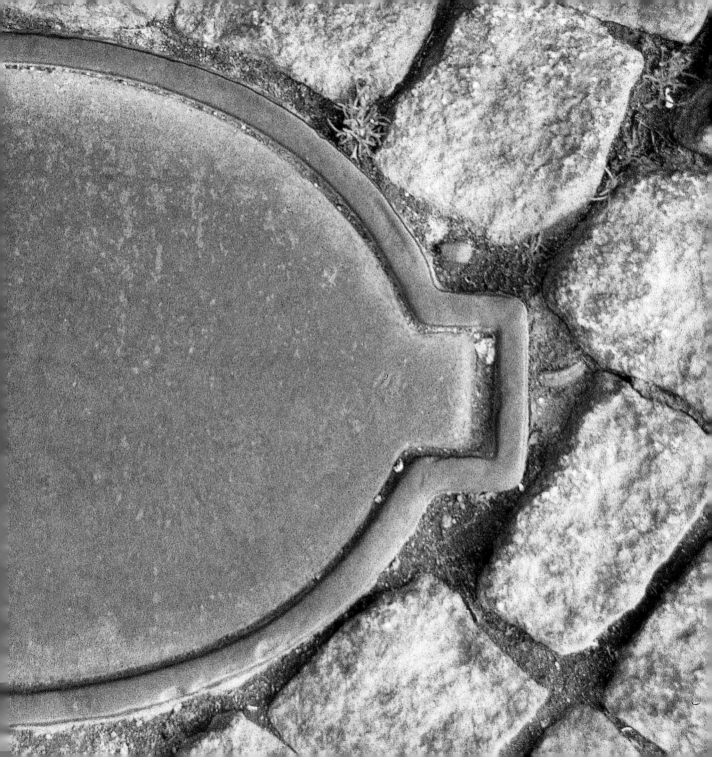

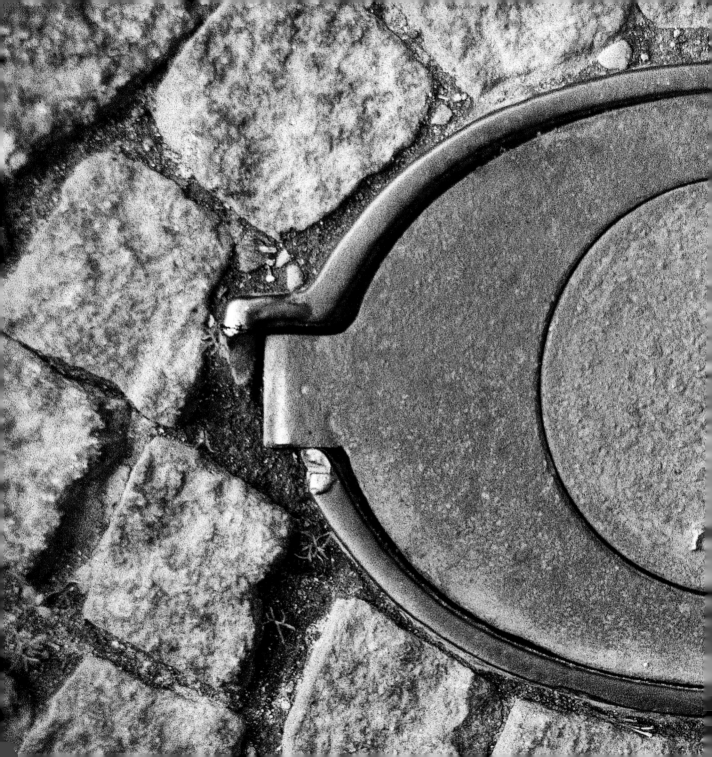

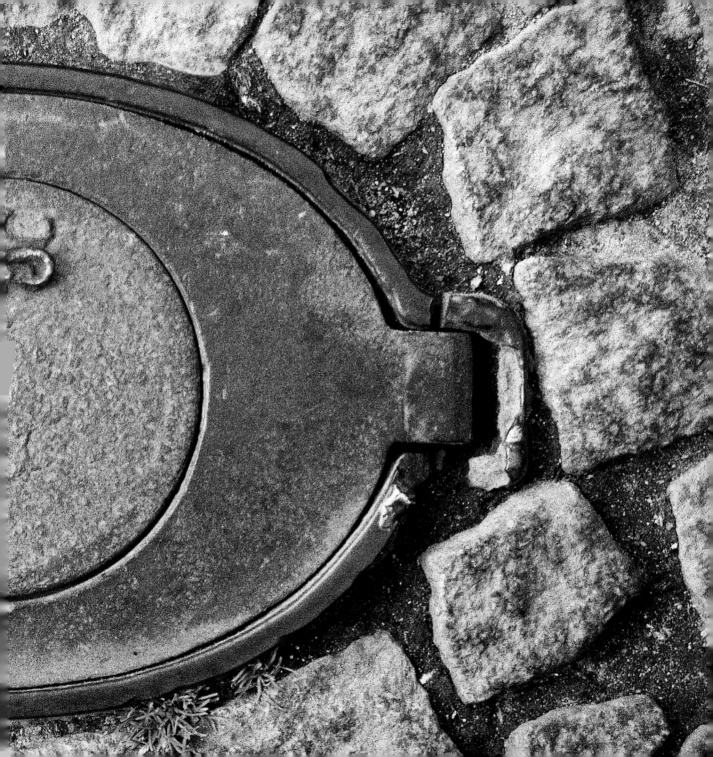

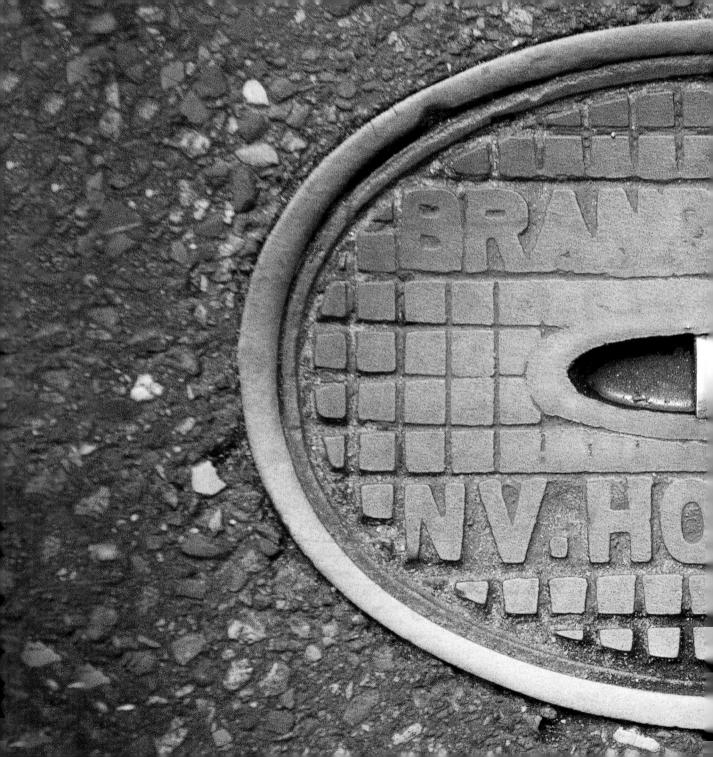

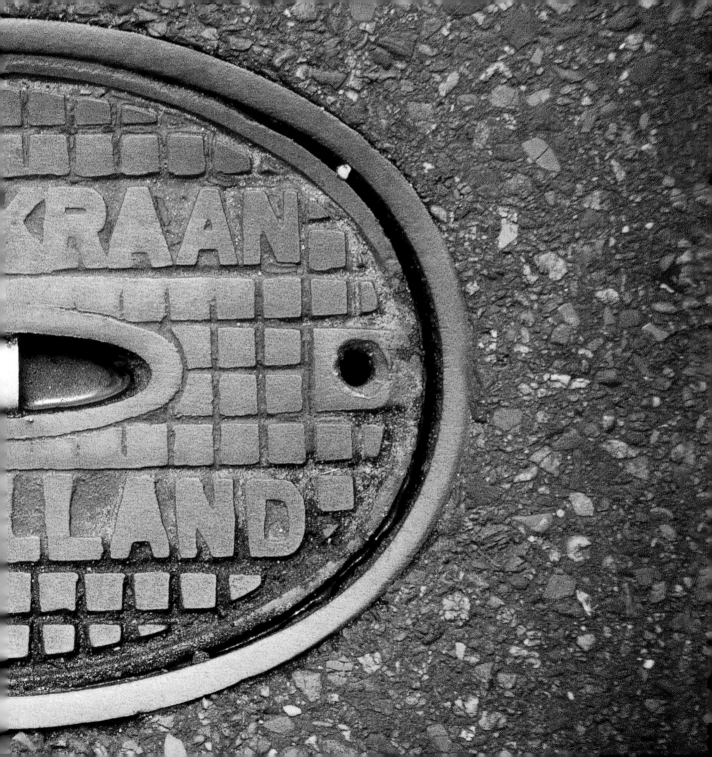

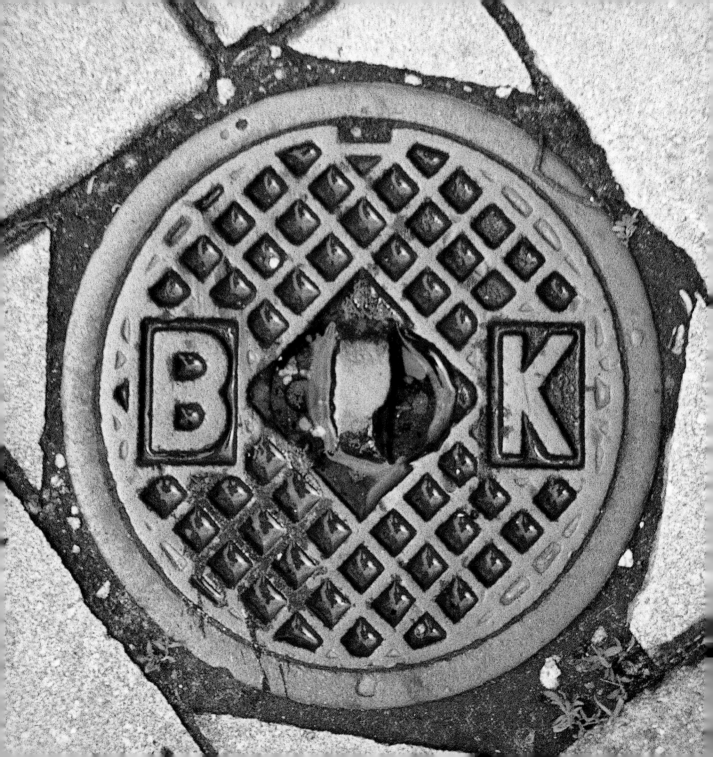

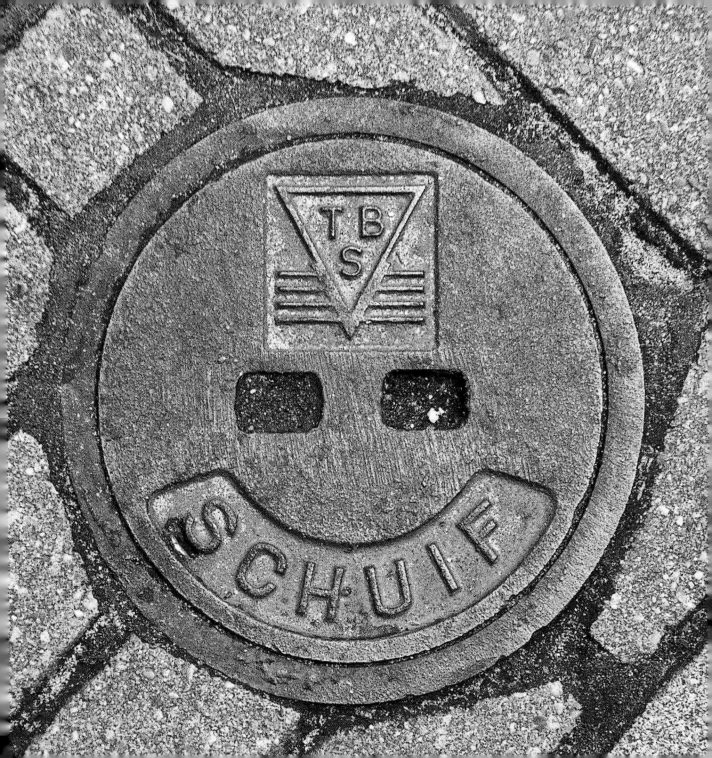

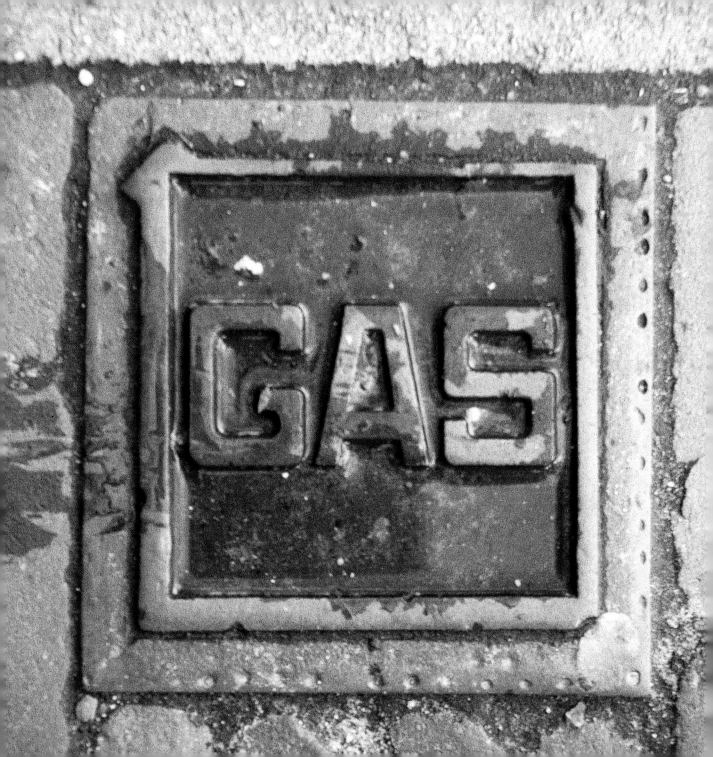

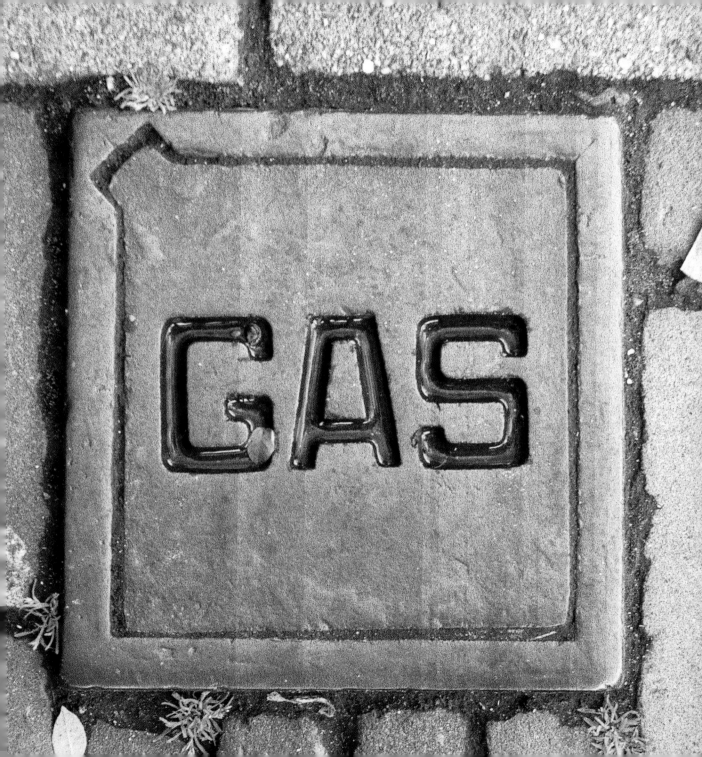

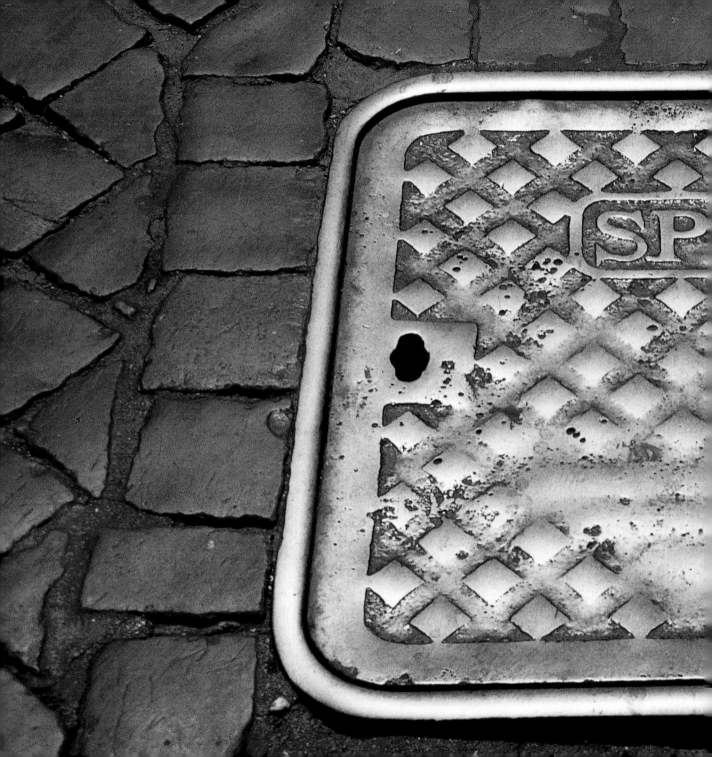

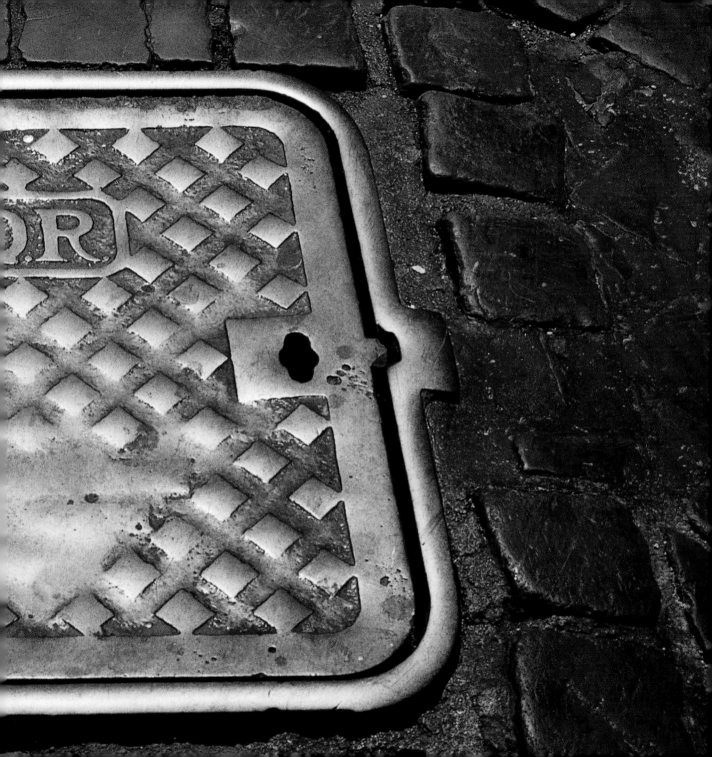

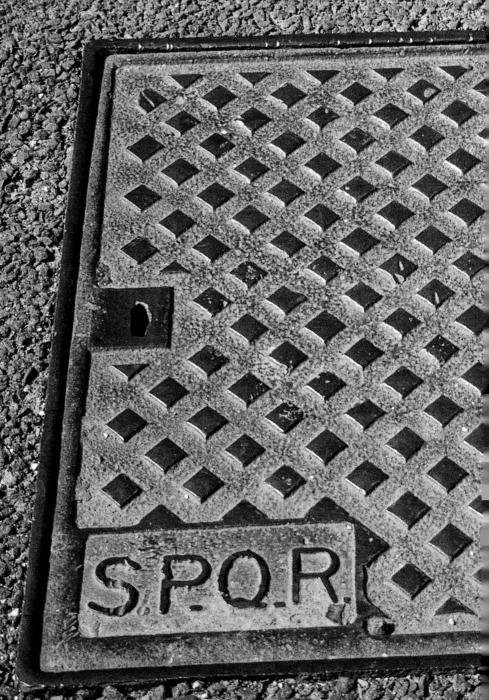

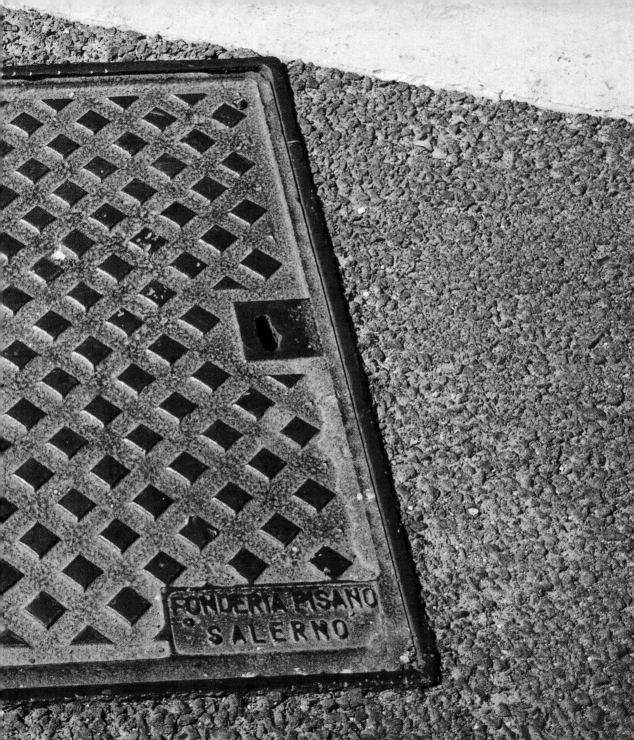

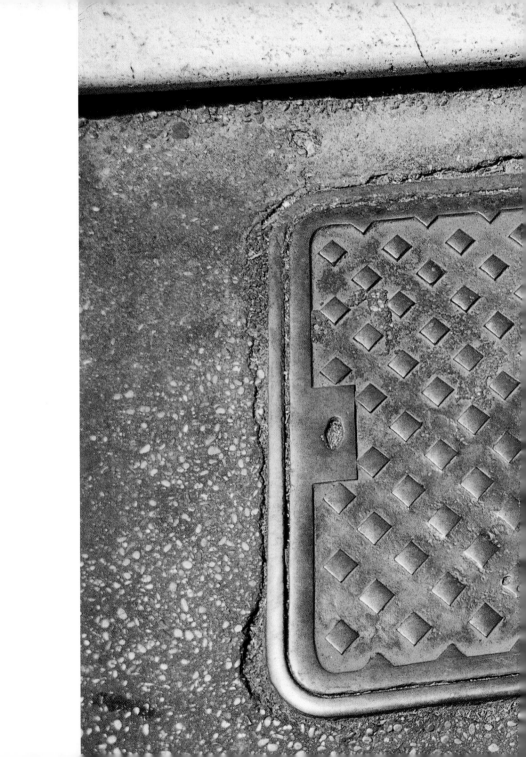

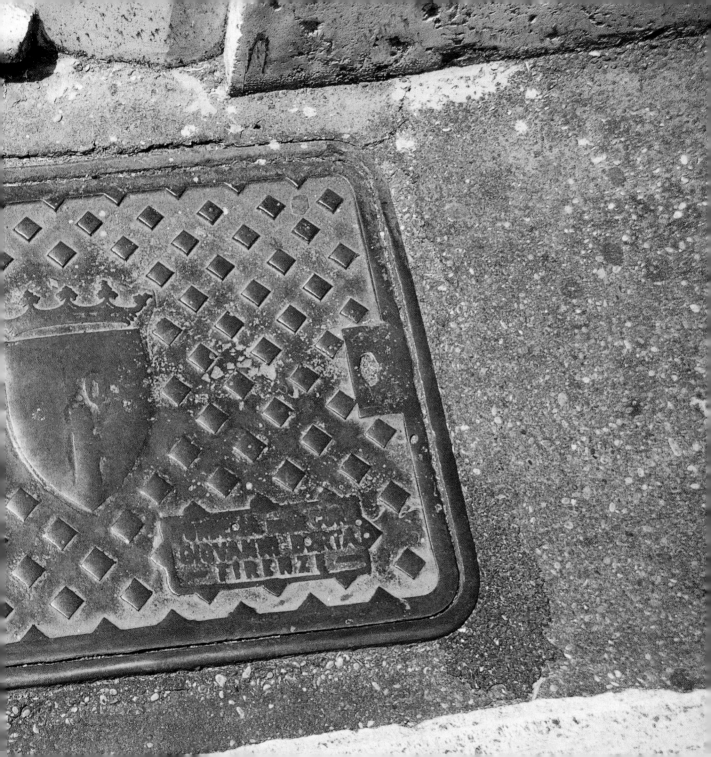

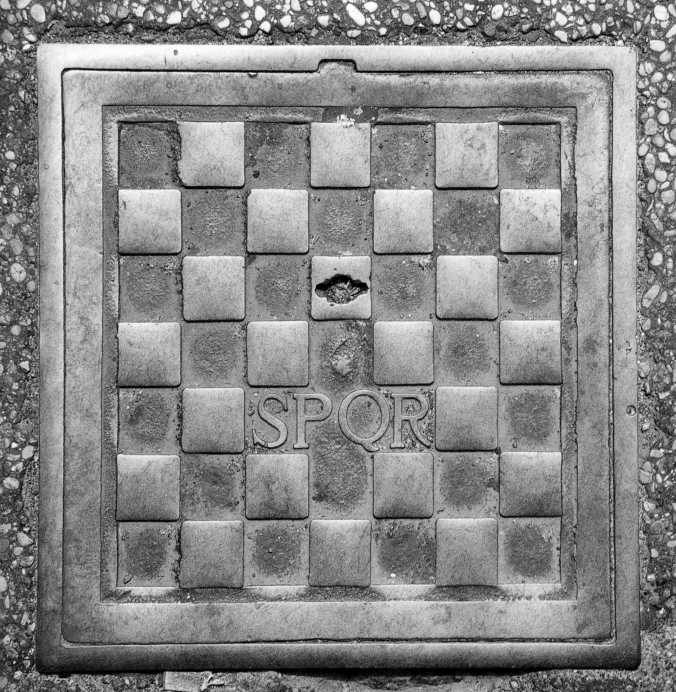

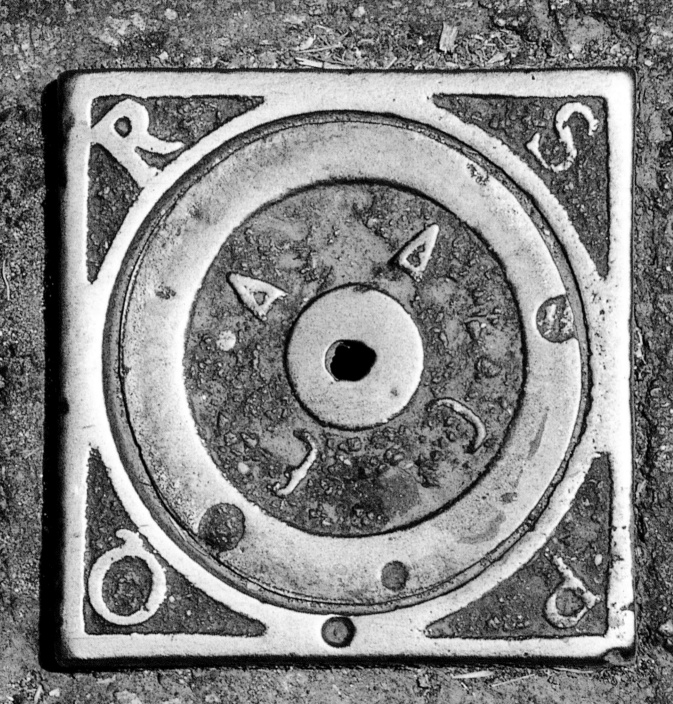

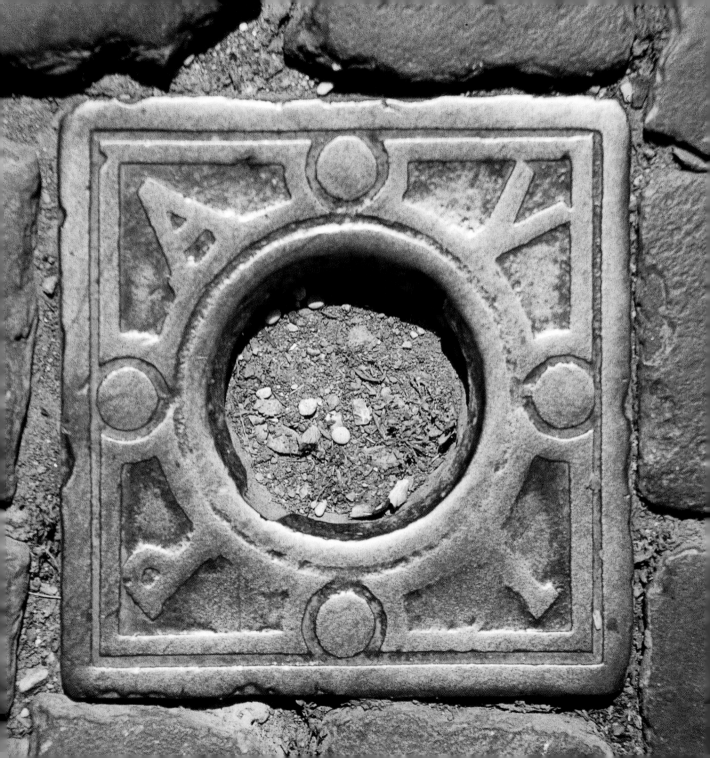

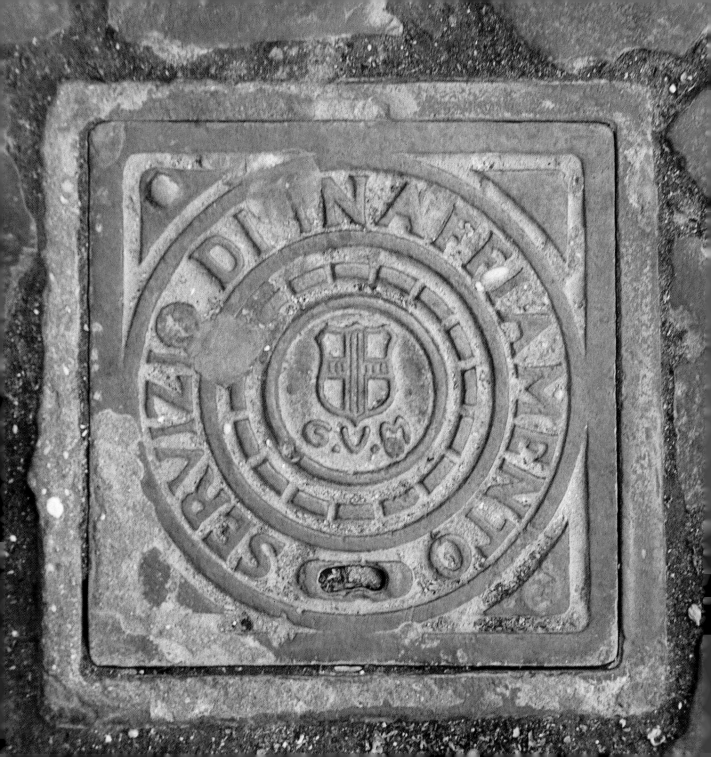

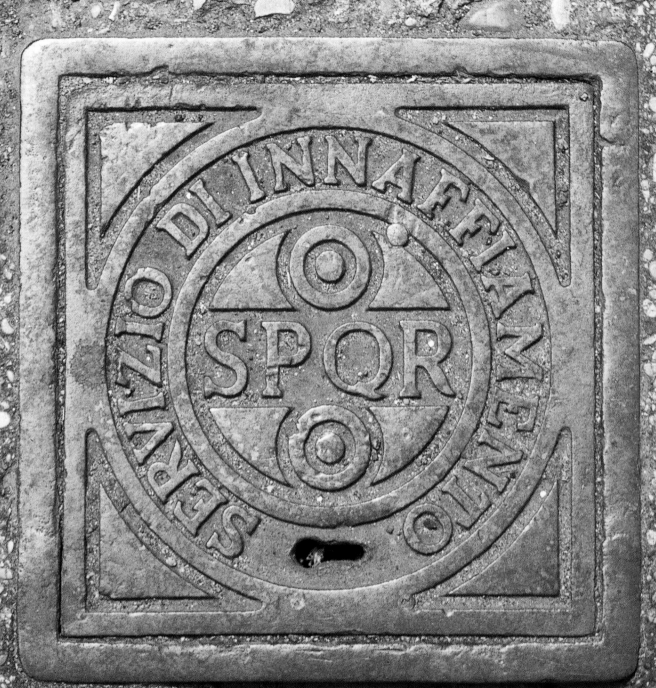

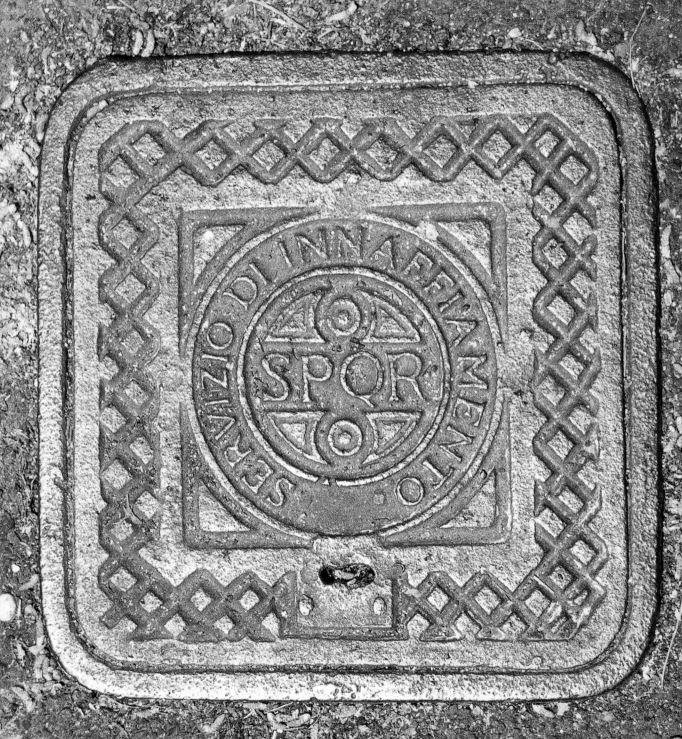

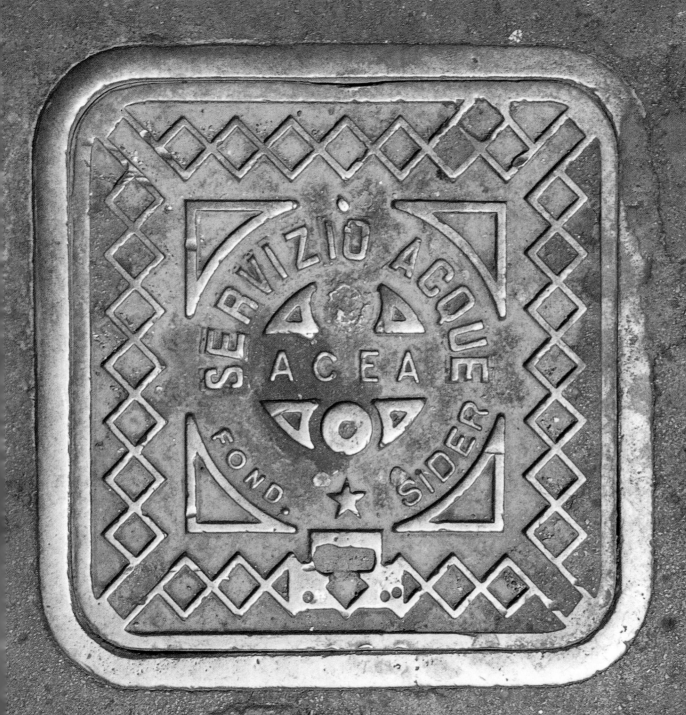

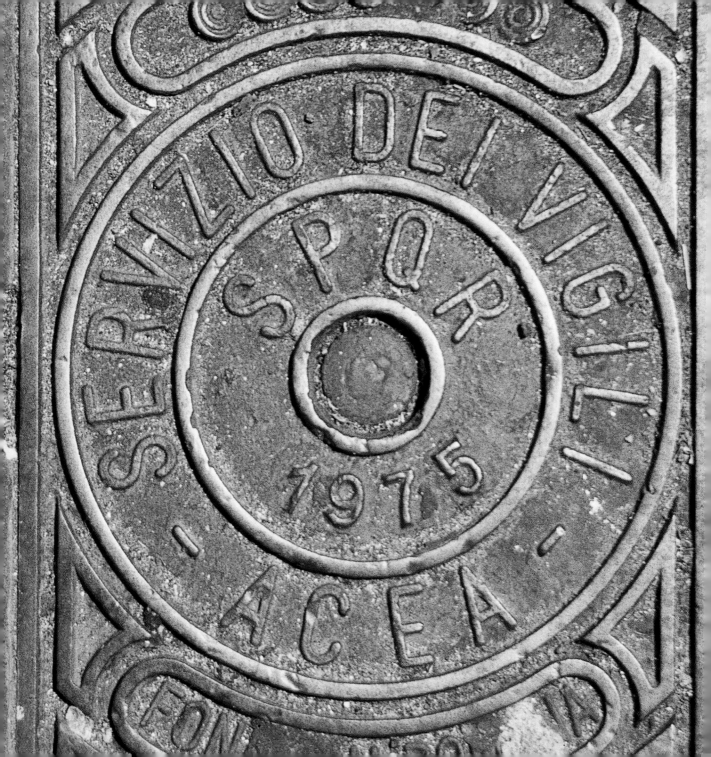

SERVIZIO · DEI · VIGILI
SPQR
1975
· ACEA ·

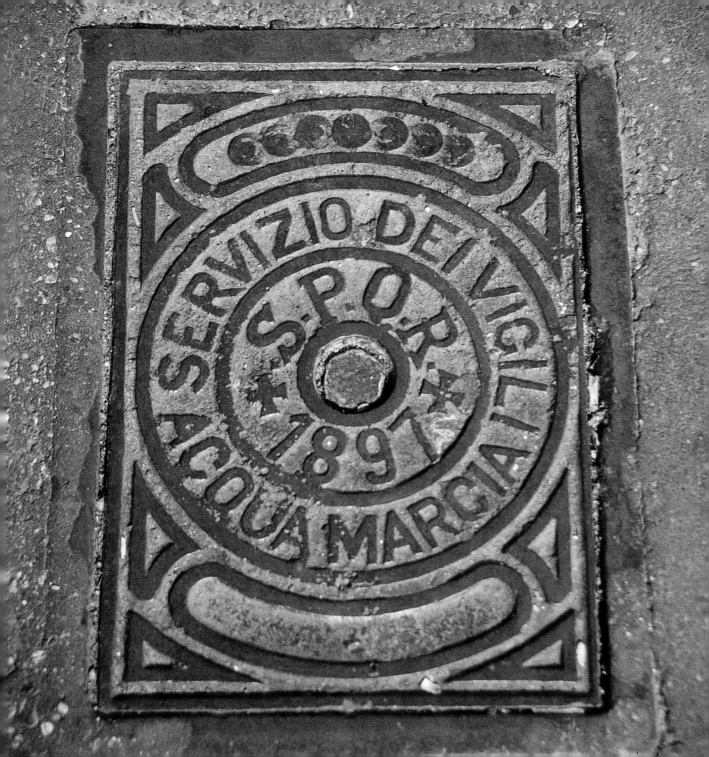

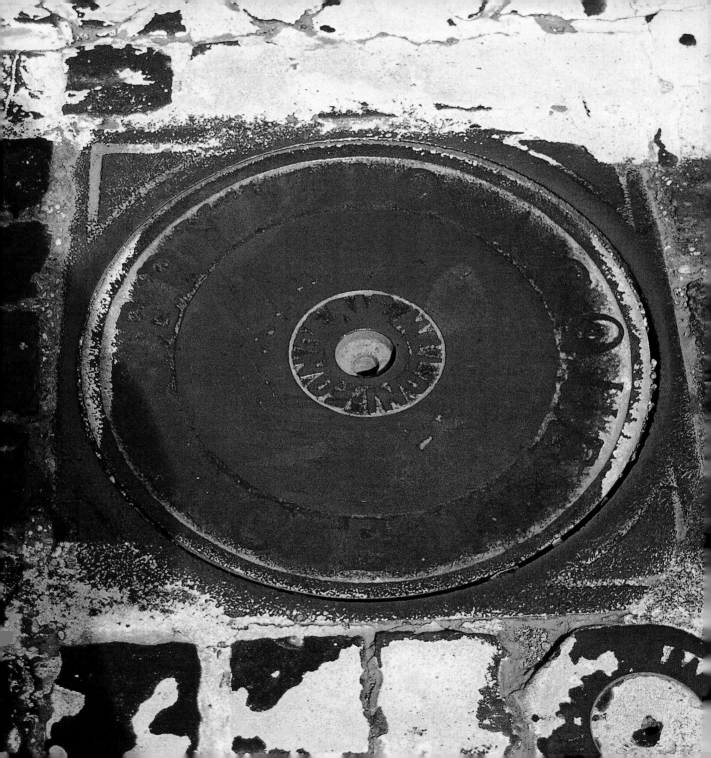

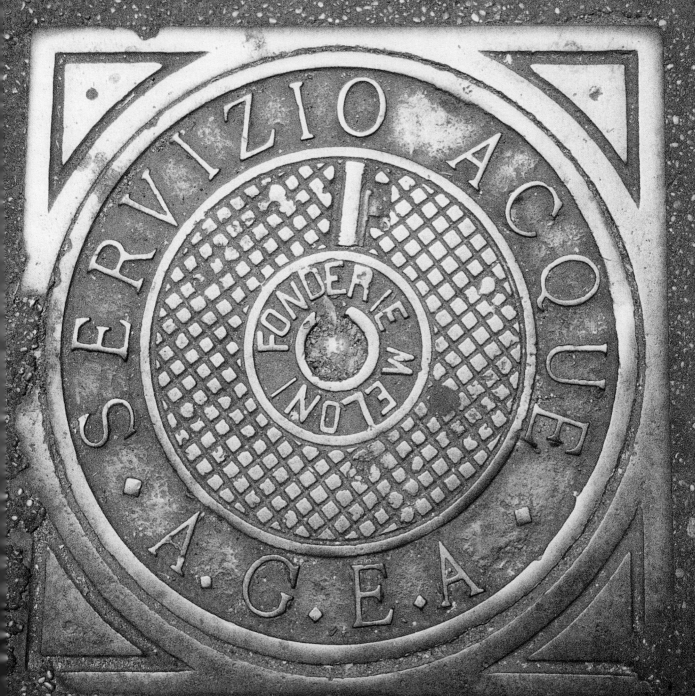

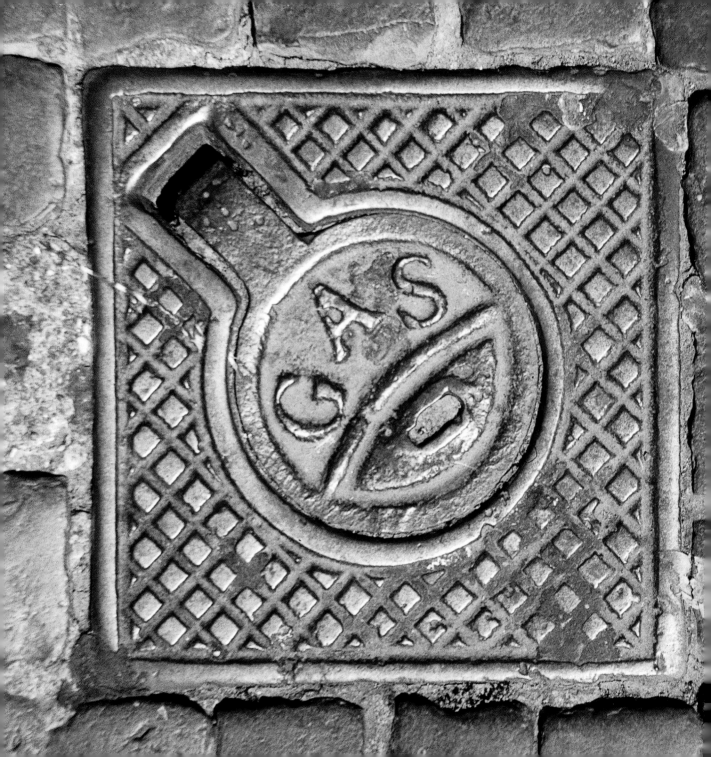

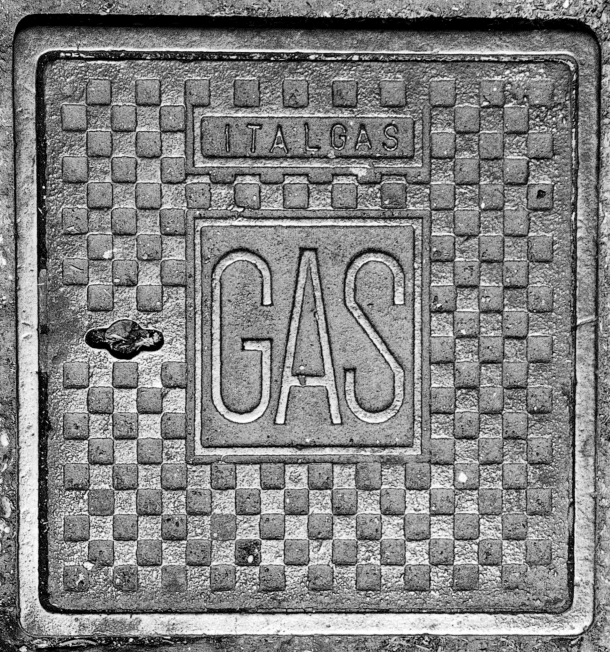

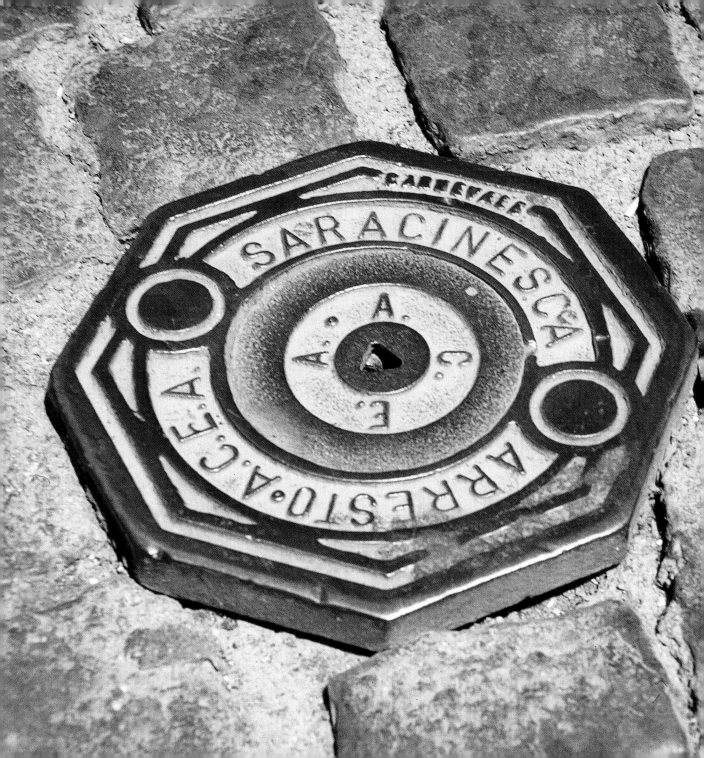

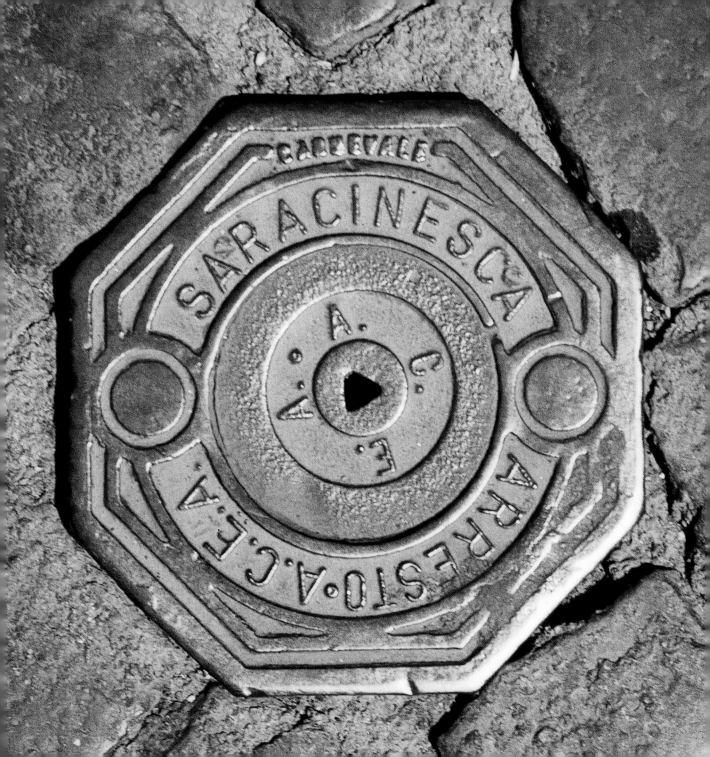

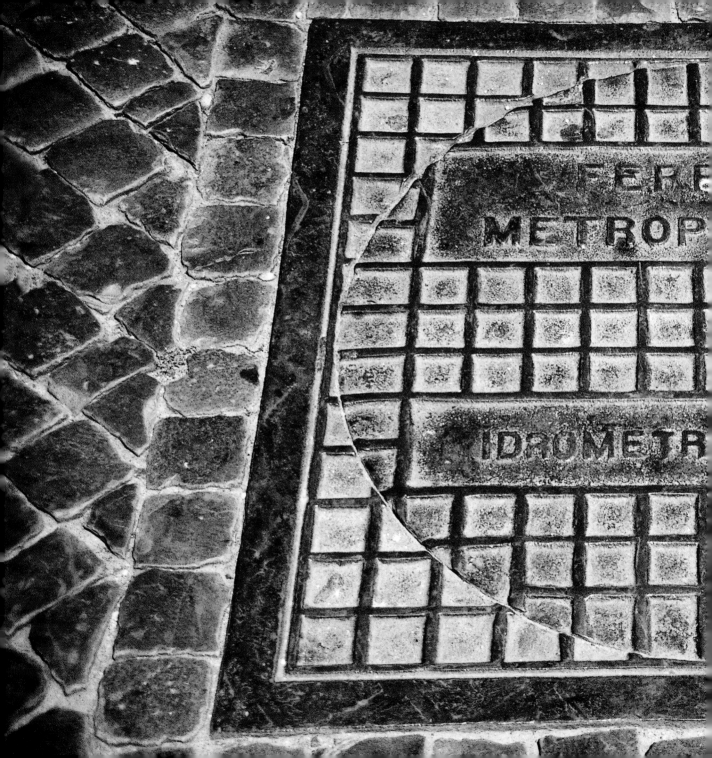

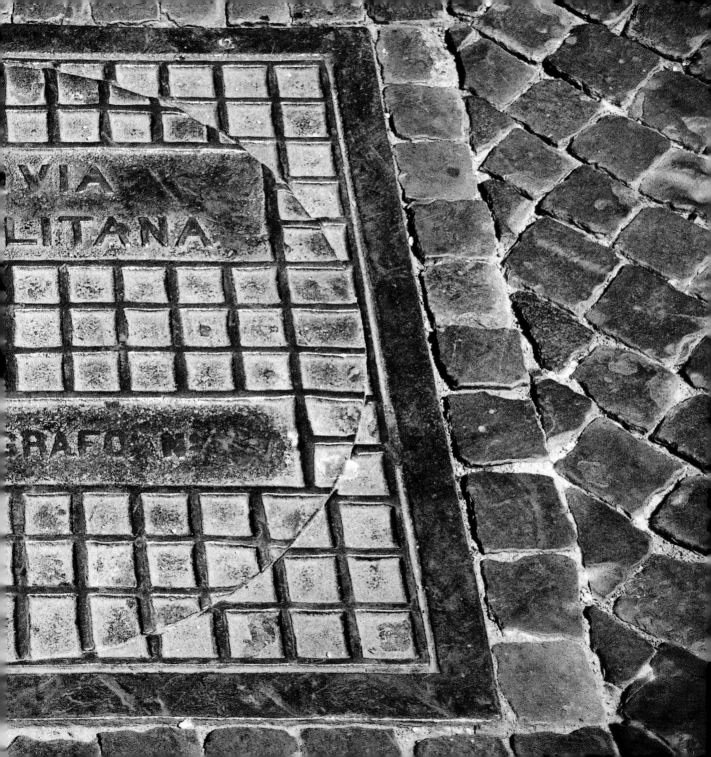

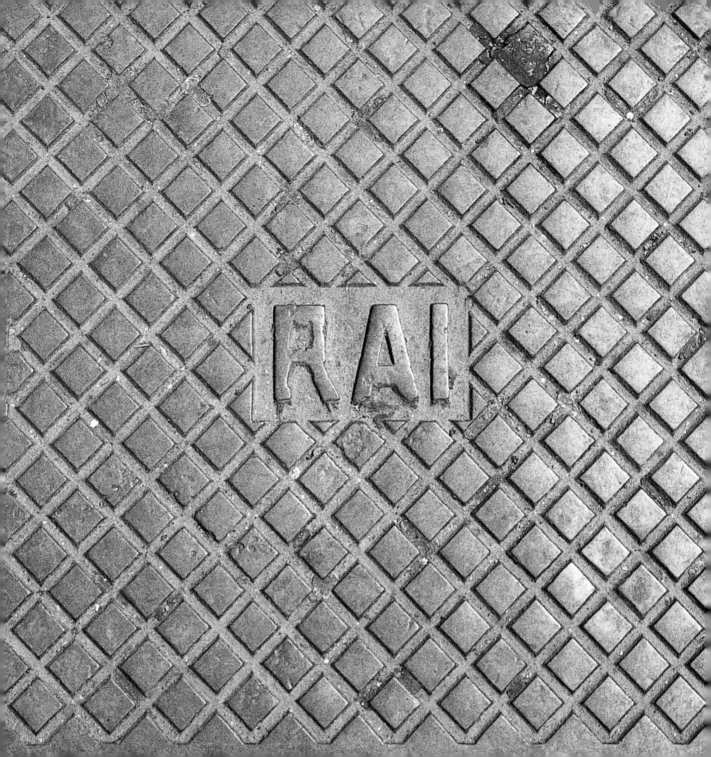

First published in Great Britain in 2001 by Westzone Publishing Ltd, 19 Clifford Street, London W1X 1RH

Photography © Jacopo Pavesi and Roberta Pietrobelli

Text © Rolando Bellini, Jacopo Pavesi and Roberta Pietrobelli, Fabrizio Todeschini

10 9 8 7 6 5 4 3 2 1

The right of Jacopo Pavesi and Roberta Pietrobelli to be identified as the authors of this work has been asserted by them in accordance with the Copyright, Designs and Patents Act 1998.

A catalogue record for this book is available from the British Library

ISBN: 1 903391 04 0

Design by Paolo Rossetti - Enterprise (Milano - Italy)

Colour separations by Euroscann, Verona

Printed and bound in Italy by L.E.G.O., Vicenza

Thanks to:

MEPRA Spa - Luigi Prandelli - Maurizio Duranti - Calogero Rindone - Leonardo Lamperti - Giulia Pontiggia - Francesco Pierantozzi - George Roman - Louis e Françoises Roman - Pierre Roman - Giorgio Giani - Martina Amati - Ettore Pietrobelli - Luisa Mascheroni - Gigi Giannuzzi - Salomè Nascimento

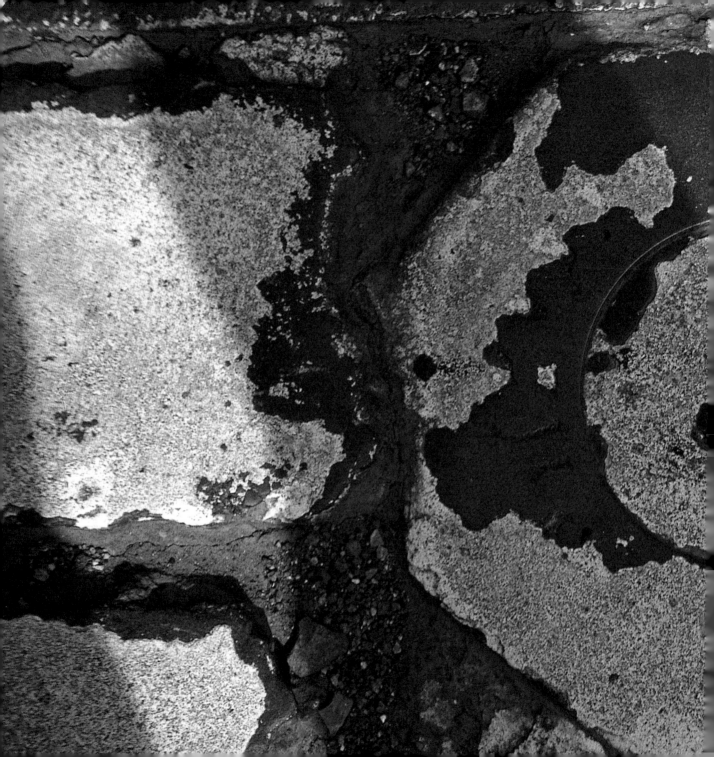